Wisdom

Andrew Zuckerman

Life

PQ Blackwell in association with
Abrams, New York

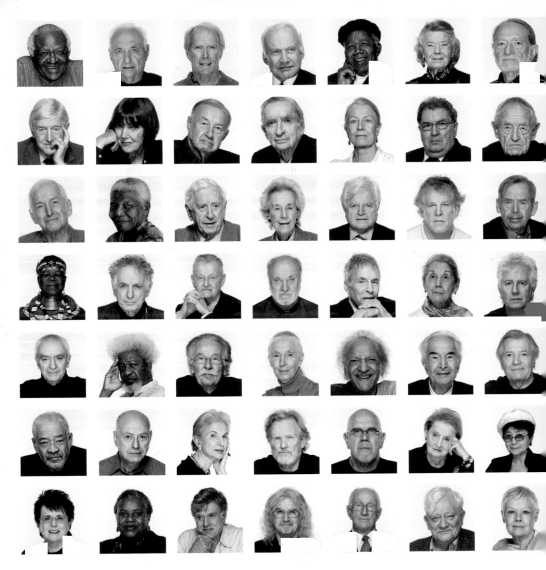

Wisdom

Andrew Zuckerman

Edited by Alex Vlack

Life

Be here. Be present. Wherever you are, be there.

Willie Nelson

Graham Nash

A lot of the world's troubles stem from lack of self-image: not being confident in who you are and what you're supposed to be doing in life. Wisdom could very well start with a little perspective. Let's understand a couple of basic things here. We're spinning around on a ball of mud that is one of billions and billions of balls of mud spinning through this universe, and the human life form is just one of perhaps many, many life forms throughout this universe. There's part of me that realizes that everything is completely meaningless, really. That if the last human being were to die in the next ten minutes, this Earth would still be spinning and it would rectify its growth pattern and human beings would be forgotten and the next life form would start, right? We need a little perspective about how unimportant what we do is. Having said that, I think it's very important to like yourself, it's important to love your family and love your friends and do things that help you grow and help you sleep. That's what I'm trying to do with my life.

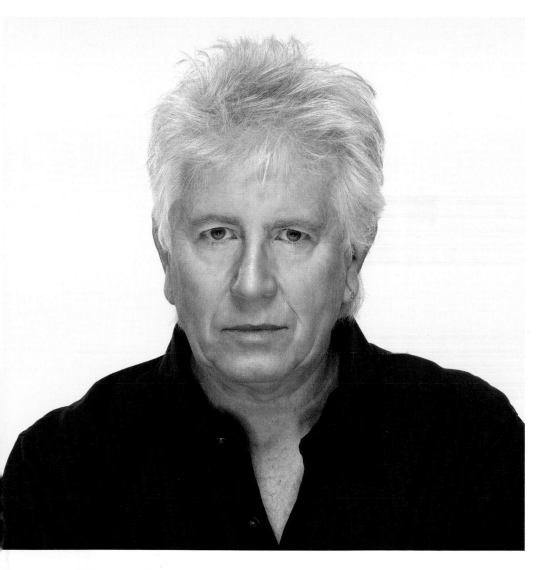

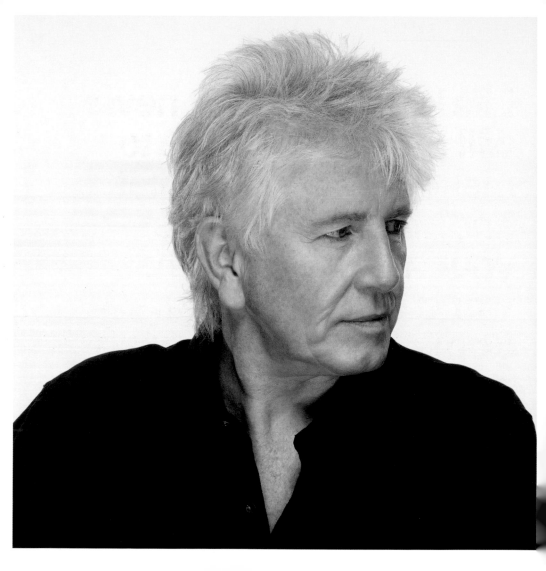

Life is not perfect; it never will be. You just have to make the very best of it and you have to open your heart to what the world can show you. Sometimes it's terrifying and sometimes it's incredibly beautiful. And I'll take both, thanks.

It's a play, isn't it? You've got to get through the third act.

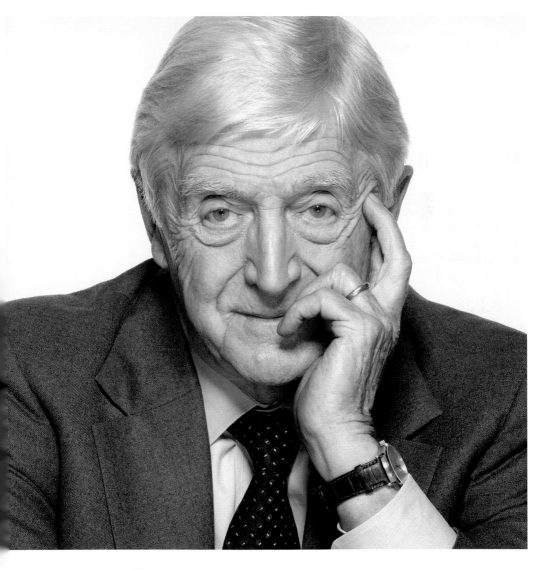

I think the one thing I've learned, and it's a very prosaic lesson, actually—it's not the one a lot of people want to know about when they talk about what separates great stars and people that aren't very good at their job—a thing I've learned is the majority of them, the people at the top of the tree, get there because they work harder than anybody else. They all have talent, of course they do. Entertainers, film stars, whoever they might be, they all have a certain amount of talent. What separates, in the end, the ones that reach a different level of stardom, in my mind: just the aptitude for hard work and concentration and actually following through on the work that you've got. The easiest thing in the world, if you're very talented, is to take that for granted, which you must never, ever do. And the people that I've interviewed, and admired most of all, have never, ever done that. Believing, all the time, that they're not quite there. It's a dedication to a job they love; it's not taken lightly. Even a great gift. You see so many people who have a wondrous gift—I can think of a football player, like George Best: incomparably the best player I ever saw, but has within him the inability to actually follow through. And then you look at somebody else, say another footballer like Bobby Charlton, who actually wasn't as gifted as Best but lasted longer and enjoyed it more because he had this pride in what he did. You see it in great stars, like Clint Eastwood. He's not just content to be the glamor-puss of movies, not just a pin-up boy, but he's gone on to become a very serious filmmaker and very fine filmmaker and is not finished yet. That's what I admire most. Dedication to the craft, to the job you've been gifted.

Nowadays being famous is almost a lifestyle, it's almost a career. Kids grow up thinking, "I'll be a celebrity." That kind of empty celebrity and the fame that might follow is dangerous. It's celebrity without substance.

I think if you become famous for something you're proud of, and you accept that as a consequence of it, you're more likely to handle it sensibly. I also think that age is important, too. Speaking personally, I didn't become famous in this country until I was about thirty-five or thirty-six and I'd got the wife and family. So I wasn't about to fall over sideways because somebody stopped me on the street and said, "Oh, it's him." It's a very strange thing. Younger people, like rock stars and people like that, I can understand why they find it difficult to deal with— sometimes it has a very bad effect on their lives. It's just something you have to understand *happens* to you. It is possible also to avoid it or to minimize it. I mean, I love going into pubs. I'm a pub man, I've always been a pub man all my life. But whereas I used to go to a pub and fall out at closing time and be carried home, I don't do that ever since I've become recognized, because about six or seven o'clock in the evening in the pub, the booze reaches the frontal lobes of your companions and they're about to do something stupid to you, so you leave before that time. So it's possible to lead a normal life but the parameters are a little bit different. People often make too much of being famous in my view, they actually, in a calamitous lifestyle, blame that, when other things are in fact at work. I've never regretted being famous, I really haven't. It gets me nice tables at

places and it gets me upgraded in airplanes and occasionally the attention of a fine-looking woman. So I'm very happy.

You're lucky, aren't you? You're genetically sort of designed to last a while. I mean, my mother died when she was ninety-five. And there was nothing wrong with Mama, apart from her brain went. She had Alzheimer's and she didn't know who the hell I was. She could sing the entire Great American Songbook, she could sing the Irving Berlin Songbook perfectly, but didn't know who I was. She lived a long time. My father died of a miner's disease, he was a miner, so I would have never known how long he would have lasted, but I suspect a long time because he was a fit man. So the first thing is, you're lucky if you have the genes and the second thing is, when you get older, if you want to continue doing what it is you're doing, you have to take stock and say how might I best manage this? It's a play, isn't it? You've got to get through the third act. You've got to finish as strong as you began. If that's the proposition, then get to work. I go to the gym three days a week. I cut down tremendously on drinking; I used to be a very good drinker indeed. I can still do it occasionally but more or less stop when I'm doing a series and that sort of thing. I don't eat an awful lot, I eat when I need to. I'm a fairly happy sort of guy. I love doing what I'm doing and I want to do it for as long as I can. So therefore I don't want to take any risks by being silly, that's all. I've been through the silliness; I've done all the booze and all that stuff. I know what it did to me and I enjoyed it—I had a ball. But it won't be the same now, that's for sure. I mean, who wants to see a pissed septuagenarian? How employable is he?

Alan Arkin

Either you're growing or you're decaying; there's no middle ground. If you're standing still, you're decaying.

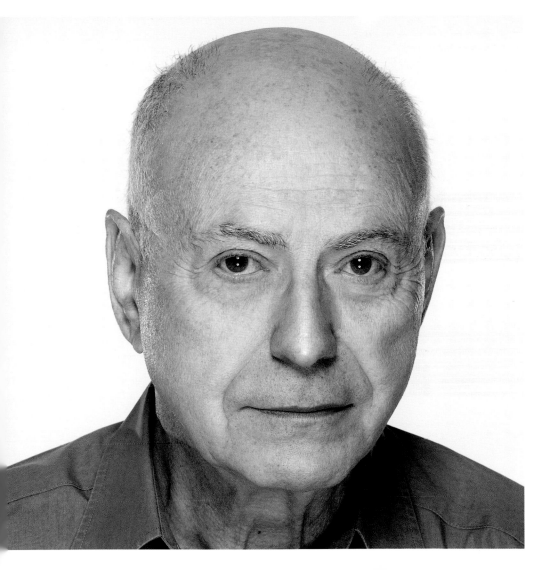

I had a very, very clear picture of what the world was when I was in my early twenties and I knew how to fix it up and I knew what everybody should do. Then, by the time I was in my early thirties, I had a totally different picture of what the world was and how to fix it up and what everybody should do. Then it happened again when I was about forty-five. So, I reached a point when I looked back and I said, "God, I had very complete and lucid philosophies three times in my life and three times I've had to abandon them and move on. So what do I live by now?" One of the things I try to do is not to believe in too much; to try and keep fluid and flexible with what's left of my beliefs because belief systems are nothing more than things I would *like* to be true. They don't necessarily have anything to do with truth; they are things I would like to be true. So I'm trying to let go of as many of my beliefs as I possibly can. I sat by my computer one day and said, "What do I know that's absolutely, incontrovertibly true?" I sat there for about an hour and a half and all I could come up with is that everything changes. That's all I know with any degree of certainty. It's all going to change, and flowing within change keeps us flexible and helps to develop a sense of humor about everything.

We're brought up in a culture that tells us, "You are what you do." When people say, "Tell me about yourself," we immediately talk about career, as if that is a complete and perfect definition of who and what we are. In many parts of the East this is not the case. Someone will say, "Tell us about yourself. Are you a painter?" And the response will be, "No, I paint, but I am not a painter." There's recognition of the separation between who the person is and the activity they're performing. They are a person and they are just doing something. That was a big lesson for me, recognizing that I am something other than, and maybe more important than, what I do. To learn not to define myself by what I do for a living, and that my work is an outgrowth of who I am, rather than it being the reason for who I am.

Chinua Achebe

If you're grabbed by art I think you should do whatever comes best to you. Whether it's a novel or a play or a song, it doesn't matter as much as the fact that you are doing something about the situation. I can't explain to you why fiction, why prose, except that that's how it came to me. The way the work imposes itself on you is part of its power, and you respect it or you fight with it all your life. So I found the novel form and it seemed to me to work. The first attempt I made when I was a student in the University College of Ibadan, I was told by my teachers from England, "This is a good piece of work, but it lacks form." And so I said, "Okay, what's form? Can you tell me what form is?" And the lecturer said, "All right, we'll talk about it next week. I'm going to play tennis now." So we didn't talk about it next week, we didn't talk about it next month. Long afterwards she came to me and said, "You know, I looked at your story and I think it's all right." So I never learned what form was. Actually, she had nothing to teach me, it was a kind of instruction to me that this is something you have to do on your own. Nobody can teach me who I am. You can describe parts of me, but who I am and what I need, these are things I have to find out myself.

My father was an orphan, so he was raised by his uncle, who was a man of considerable importance in the town. And then the missionaries came and one of the first places they went was my father's uncle's house, because he was a prominent man. The missionaries wanted to use his home as a base and he received them. And then he didn't like their singing. He said it sounded like somebody died in this place. So he sent them away with his best wishes. But my father was fascinated by these people and their story. And to cut a long story short, he became a convert. Now, his uncle did not try to stop him, even though these people sang terribly. He let my father go with them because that was what he wanted to do. And so you had these two people, my father who became a missionary teacher and spread the Christian gospel in different parts of society, and his uncle who refused to join this new faith. My father even tried to change him, and my great-uncle pointed at all his titles and said, "What do I do with these?" I admire both people. First my great-uncle, who stood fast: "This is what I know and that's what I will keep. If you want to go and learn something out there, fine, go and good luck." And my father, who joined the Christians because he thought their message, the gospel, was going to be valuable to his society and got an education and started me and my siblings on the road of education. I don't choose between these two. Each dealt with the situation that was presented to him.

Nobody can tea

h me who I am.

Frederik Bolkestein

I don't think it would be wise to try and define the concept of wisdom. One has to deal with many different situations and many different people, and what is wise for one may not be wise for another. In particular, one should be cognizant of the fact that some people believe in a God and others don't. I am an agnostic, that is to say I do not know whether there is a God. I have no knowledge of that. But certainly I do not believe in a God that interferes with human life, as many people do. So there's a great difference between believers and non-believers. And what is wisdom for a believer may not be wisdom for a non-believer. There are also many different cultures. And what is wisdom for an Indian or a Chinese person may not be wisdom in my case. And, conversely, my idea of freedom may not sit well with an Indian or a Chinese. So one should be careful not to be categorical in an area where there many different views, visions, and ideals.

I grew up steeped in classical literature. And the Greek philosophers, of course, discussed at length the concept of wisdom. And what somebody like Aristotle came up with is that we should try and avoid extremes. The expression was: "Nothing too much." The best thing is not to search for the best nor for the worst, but the middle. And while that appears to be very useful advice, to my mind it leads to a somewhat anemic world. If we are all happy with the middle—if we avoid both extremes—that may make for a safe society, but also a boring society. By and large, we should try and be ambitious and try to get the best out of ourselves. Because if you do that you can achieve a state of being which must be related to something like wisdom.

Wisdom is in the constant questioning of where you are. And when you stop wanting to know, you're dead. You're walking, but you're dead.

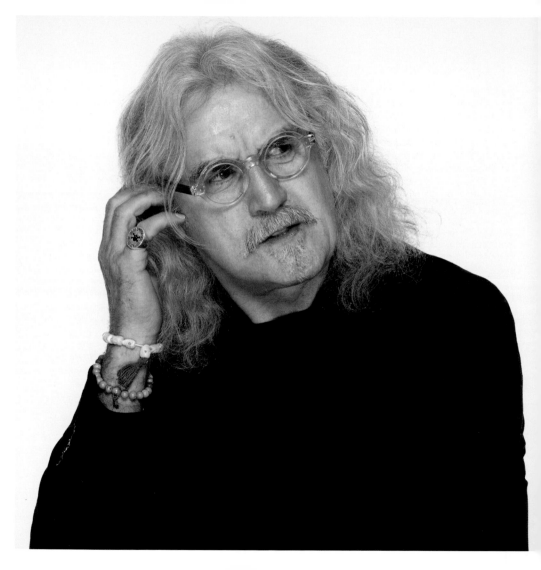

As far as I'm concerned, wisdom isn't an old guy on the top of a mountain with a loincloth and waist-length hair. Wisdom isn't an answer. Wisdom is a question. I went to see a shrink once. I was bothered by things in my childhood and my youth that kept coming back and seemed to be accelerating and bothering me more, and I went to see a shrink. And I was so disappointed that the shrink didn't have a big bag of answers. I came to be very grateful for it later, that what they have is a big bag of questions. You have the answers.

And that is when I found that the answer is invariably in the question. People who ask you things often have the answer, but want it verified by you. I've tried to tell my kids, "Avoid people who look as if they know the answer, or who would have you believe they know the answer. And seek the company of people who are trying to understand the question." You carry your own question around with you. Sometimes it's just because you're ugly. I grew up as an ugly guy. I don't see myself as an ugly person, but Tony Curtis was what good-looking was. Elvis Presley was handsome. I wasn't. I was a welder. I had a welder's face. And my question was, "Why?" You know, just looking in the shaving mirror—why? Why don't I? I knew guys with one eye who were more popular with women than I was. Why? Why didn't I have an attractive scar or something?

There is no answer. It's like your mother saying, "Where have you been till this time of night?" The question was the answer. She didn't want you to tell her. The question was the answer, and that's where wisdom is: in the constant questioning of where you are. And when you stop wanting to know, you're dead. You're walking, but you're dead.

There's a thing in Buddhism that says, "Find what you should be doing and do it," and it baffles a lot of people. I try to tell my children, "Just try and see what you're drawn to—the type of store window that you're drawn to." Like music stores, antique stores, tailoring stores—whatever it is you keep being drawn to. Because it's no mistake when you're drawn. Something's telling you, "This is the direction you should be going." It might be pet shops, it might be funeral parlors. Just try and notice what you're drawn to all the time. Because that's the way your life should go. And when you do something that you feel vocationally drawn to, it's not like a job. It's what you should be doing. It's your *raison d'être*. It's the reason to wake, and you wake up feeling good in the morning, which is a wonderful thing. When I was a welder, an awful lot of the guys I knew didn't like being a welder. They didn't like their wives. They didn't like where they lived. And I thought, "God, imagine that's your life!" I found it quite frightening, the thought of going through life not liking your wife and not liking where you lived and not liking what you did. How do you wake up in the morning, going, "Oh God, here we go again"? You'd be on your deathbed saying, "At last! The day I've looked forward to all my life!" wouldn't you? I don't want to say that. I want to say, "Oh Jesus Christ, is this the time already?" When you're lying in your deathbed, say, "Is that it?"

Frank Gehry

An old friend—who was like the elder in my tribe, I called him—a number of years ago made me understand how other people saw me. That was an enlightenment of some kind, and it was painful at first to understand it. It's respectful of the other person to understand what they're thinking of you. If you're full of baloney, they know it, people usually know it. But if you don't know that they know it, you're wasting your time.

The most important thing a person can do is understand how they're coming across, because once you do you can present ideas. It opens the game very big.

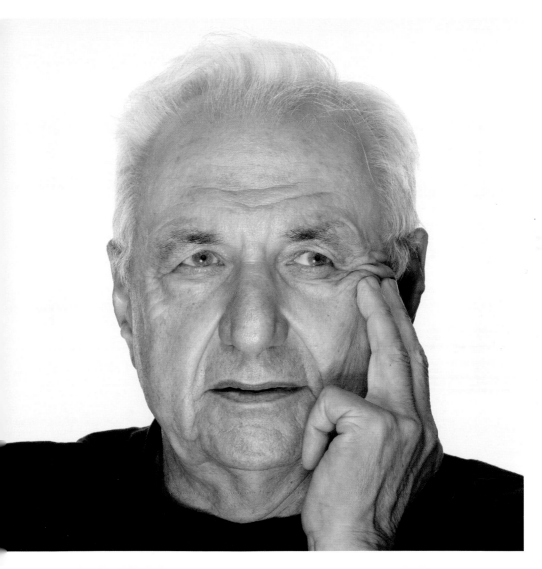

Nick Nolte

We have great technology, we have great ability to handle things on the outside, and build cars, build roads and stuff, but we don't have any approach to what's on the inside of a human being.

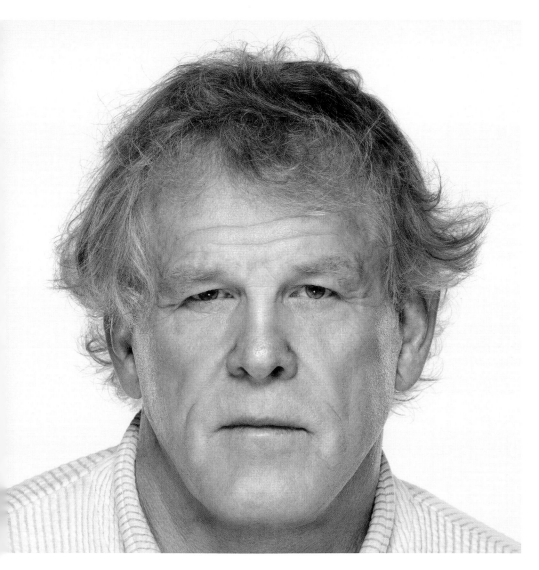

We have religions, but they are religions that are so steeped in traditions that everything has been put on the outside. Truly, the East is about finding who you are, spiritually inside. You don't even have to use the word "spiritual." It's about finding who you are. The reality of who you are. And when you reduce it down, it becomes that the miracle is life itself. It's not in heaven, it's right now. It's immediate and so it's living each moment. And that's what was brought into this country in the sixties, you know, "be here now," this whole idea of living for the moment, which was contrary to our culture, which talks about becoming something. When you have a little child and you look at that child and say that it has to become something…it's already something! It's already what it is. So this is what we have to learn from the East: all of this acceptance, and with the acceptance comes peace. And peace is an inside job. It exists somewhere inside. You can't negotiate peace, because a negotiation, by the simple fact of negotiation, means it's going to break down. Somebody's going to be dissatisfied. Peace is something that you find for yourself.

Crick, he wanted to answer two questions in his lifetime. One, "What are we made of?" and he discovered DNA. The next one he wanted to answer was, "What is consciousness?" So he was studying neurotransmission, the point of neurotransmission, and some of the technical ideas are that consciousness is nothing more than the neurotransmissions that are happening at this moment and that the brain is very plastic, and so consciousness is moving around, whatever we're thinking about, okay? But that's not really what can define consciousness. Consciousness is something you gain by experience and focusing on your own individual being. You know, trying to watch your own self being your self. Which is very frustrating, because then you have the observer and the observed, and you soon realize: are you the thought or the thinker? You are both; you are one thing. And that frustration leads you to surrender, and you surrender it and then that is what consciousness is about: surrendering and accepting. And then it becomes larger and larger and larger and larger. And you become more and more conscious of everything. There's nothing wrong with the mind, the mind is fine, it's a good tool and everything, it's just not everything. We have a thing in Western society that the mind is everything. Well, as an entity, as a being, the mind is rather petty. It's greedy, it's egotistical, short-sighted, and wrong most of the time. There's a space that's beyond all that, that once you recognize that the mind is like an organ, it's like your heart and it serves good functions but it's not everything. Then you begin to feel, where is this presence that I am? Where do I reside in myself? Where am I? I've got a pool out here and it's ninety-eight degrees. I have an oxygen tank, medical oxygen tank, that I put in my nose. I breathe in oxygen, and then I take these rolls that float and I put them underneath my heels and one under my neck and one under my back, and then I have a silk cloth that I pull over the top of me and I cut a little hole, so I can breathe this oxygen through here, and the silk cloth keeps me warm because that part of my body's exposed. And I'm in this ninety-eight-degree temperature and I'm hooked up to a tube of oxygen, it's the umbilical cord, and as you float in that water you begin to feel a vague experience you've had

before, and it's definitely a womb-like experience. Meditating and looking at the universe that way, looking up at the sky that way, you perceive that if you weren't there you wouldn't see it. So you are that. You are what you are seeing, there's no difference. You are it. So your awareness and your consciousness is everything, it's all of it and it's all forming into one. Everything is moving in a very peaceful way and you have a serenity. There is a true serenity that you can find. I am not able to stay there, because this is the world, I'm human, and we human beings have to drive on freeways and some guys think that it's "my lane," you know? Well, no, it's not "my lane," it's everybody's lane, but some people think it's "my lane" and how dare you pull into "my lane?" I have heard life described as being on a platform just the size of your feet on a pole three miles high; and that's what consciousness is, and awareness: how to stay on that pole three miles high on a platform like that.

True compassion is recognizing the true peace in yourself. Once you can see the peace then the compassion comes, because there won't be any difference. Even if a person has killed people, he has a space in him that is as sacred as the space you have. There's many examples of guys in prison finding peace within themselves, if they look for it. So compassion is recognizing the peace within yourself and that allows you to see others.

I was very fortunate, I grew up in a magical town, a small town in Iowa—Ames, Iowa. And in the forties, in ten minutes I was out of town. I was either in the woods or I was by the Tarzan tree, or the creek, or I was at the lime pit, or my mother used to take us out to the creek and out to where the cave was and we'd have a picnic as kids and it was always an adventure. It was always, what's in the cave, what's over there, what's over there, what's here, what's there? So that's where my curiosity came from. Just the curiosity of everything.

There was an experiment done with mice and they were trying to find out how mice grew dendrites in the brain. They wanted to know what conditions caused the brain to really grow. So they took one mouse and they put him in a cage and they gave him everything he wanted: food, everything, he had everything. They put another mouse in a cage; he had everything, but he had to run a treadmill. And then the third mouse, they put him in a cage and twice a week they took him out and put him through a maze, but not a maze that was just going like this, it almost threatened his life. I mean, he had to go up a pole and he'd be twenty feet above a tub of water below, and, you know, enough to put a little edge to it…and they had MRI'd the brains of these mice, and afterwards they sliced up the brains to look at dendrite growth. Well, the mouse that had everything, he didn't grow a single dendrite, didn't grow at all. The mouse that had to run, he grew dendrites, but he didn't connect them. And the mouse that had to survive, he grew a lot of dendrites and connected them all. So acting has that little fatality in it that you might not pull it off. You could fail horribly here. And embracing that uncertainty is actually the creative process. That's what gives you the juice to go. And if it doesn't scare you, then don't do it. Even as you get older, that's still there.

Judi Dench

I feel that I'm constantly learning, in every single thing I've ever done. I've never, ever, in fifty-one years, done a play that has come easy to me. And I've fallen over in every play I've done except three in fifty-one years, too; in *A Little Night Music* I fell over three times. I can't keep upright.

To learn the craft of acting, the one thing you must always do is just watch. Watch all the time, watch what other people do. When I was at the Vic I used to stand at the side of the stage and watch all the time. Not just your scenes, but all the scenes you're not in, because you always learn. And always, with a play, if you watch and you listen to the audience, you know what the pace of the next scene should be. It's an all-embracing thing.

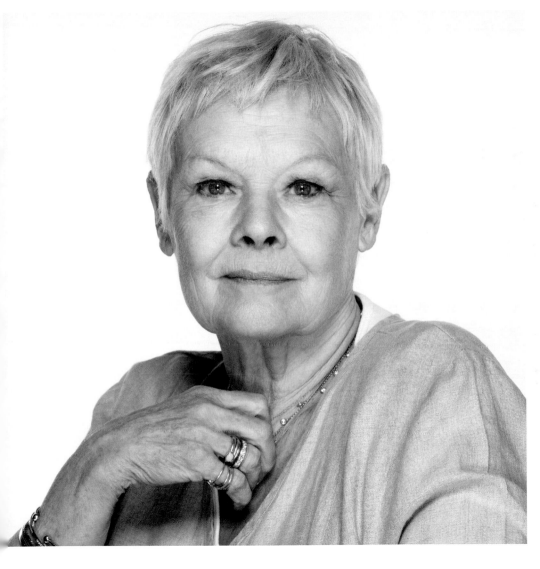

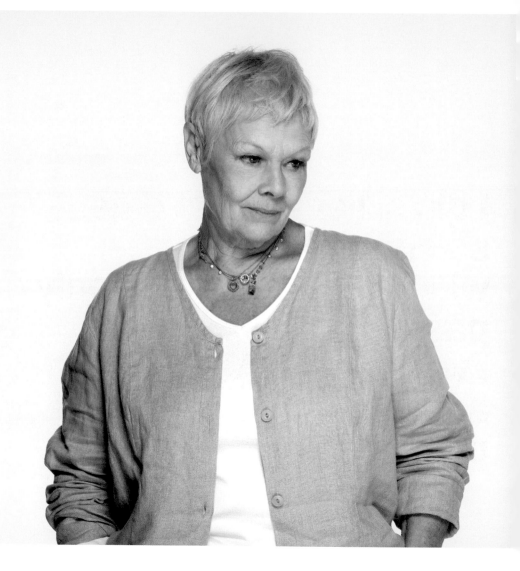

I get sillier as I get older, so I don't know what wisdom means. I can only pass on something that I've been acquainted with and let whomever it is pick the bones out of it.

Desmond Tutu

Happiness is when I see others happy.

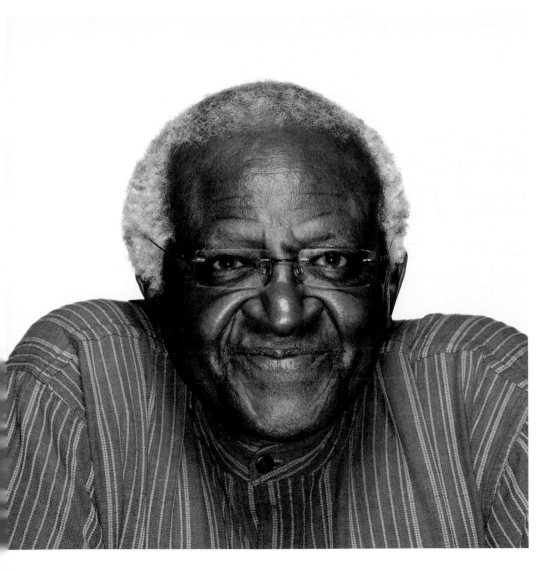

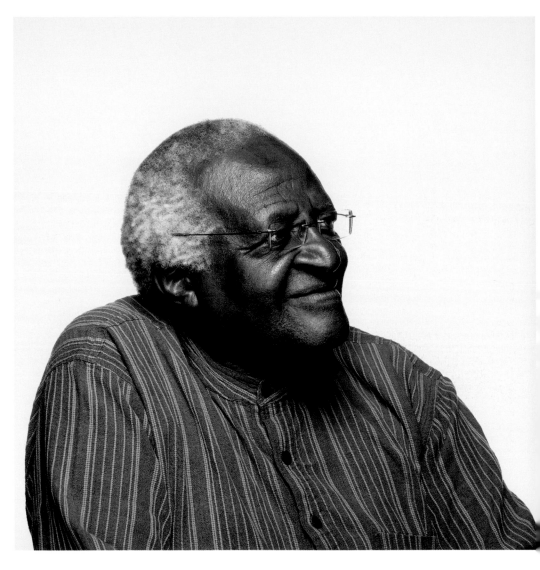

There is a saying, that we ought not to try to reinvent the wheel, but most times we human beings can be quite silly in getting to make the same mistakes that were made by previous generations. And no wonder a wag has said, "We learn from history that we don't learn from history." This project is saying, one of the greatest gifts we can give to another generation is our experience, our wisdom, the wisdom of an older generation. In the traditional village there used to be those who are called elders. They were no longer fit physically to do strenuous things, but they were looked up to because they were seen as the repositories of experience, wisdom—which they wanted to share with succeeding generations. They would say to young people, "Sometimes the best way of winning an argument is not to have an argument at all." It seems so obvious: most of the time, when you are provoked, you want to give as good as you got; and that often does not resolve the problem, it just exacerbates it because the other person also gets upset and wants to give back as much as they've got. A soft answer turns away wrath. And those who are elders are so deeply passionately in love with life, so deeply and passionately in love with succeeding generations, that they want them to prosper, and so they say, we have learned over the many, many years that in fact generosity, compassion, gentleness, and caring are so much more powerful than their counterparts.

Happiness is when I see others happy. Happiness is a shared thing. I find it a very diminished happiness if it is something I enjoy myself. When you bring a gift to someone for their birthday and you see their face light up with joy, it's quite incredible what it does for you, the giver. Jesus did say, actually, "It is more blessed to give than to receive," because in giving, although it doesn't seem so, you receive. And for me happiness is that feeling you get when you see someone else happy; and happiness is when you are serene, peaceful.

Serve others. The unfailing recipe for happiness and success is to want the good of others.

Most of us give up too early. Failure is an absolute essential in life.

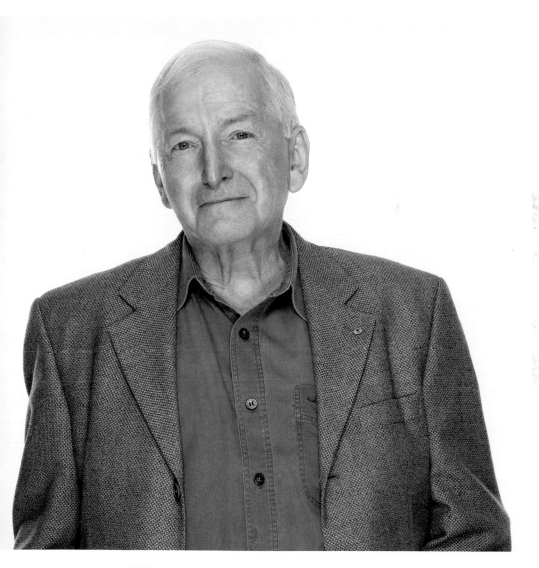

Wisdom is a very specific thing. It's not about brains. It's not about the accumulation of knowledge. It's about being decent. And let me explain what I mean by being decent: if you can be generous and nice rather than a son-of-a-bitch, it works better for you in the end. People have always said of my whole life, and it's been a very strange journey, "You are too kind, Bryce." Now, that sounds terribly presumptuous, but if you can be pleasant and nice—you're going to be conned, absolutely, for sure—in the long run, over seventy-five years, it's a better journey and in the end you win more. In hard fact you actually win more: you win more friends, you win more opportunities, you win more life, you win more joy, you win more character. It's a very curious thing, the world is predicated on the basis, "Watch that bloke, he's very suss, he's very suspicious, and he could be taking you." I've always said, "Take me. Let me have a look at what it's all about."

I traveled as a creative director for some large American agencies and suddenly realized that I was going all over the world, but was spending four days in a boardroom and catching a plane—I saw absolutely nothing. So I made a criteria as a fairly young advertising man that whenever I traveled I would, at the end of whatever I had to do, take two days at the end of it, regardless, for myself, and have a look around. By the end of fifty years I had a book with addresses of everybody I'd met

who I liked, for fifty years. Every day I would write, starting from A going to Z, two postcards to two people in the book; and occasionally I'd get a letter back. I was communicating with these people I'd met all my life. Travel, for me, is people. Now, may I tell you a lovely story? In 1956, I'm in Kathmandu and I have to go to an advertising event in Pakistan. I shared a room with a Pakistani guy and all he wanted to do was have a good time. He was wasting his time. He's supposed to be at London Polytechnic or something, and I was going through university. He offered to share his room with me and it was cheap and I could do that. Suddenly, I'm in Karachi, thirty-seven years later. I'd written him a card saying, "Hey, look, I'm coming to Karachi if you're there." I've sent him a card every year, but haven't heard from him. I arrive in Pakistan, and the human donkeys are on the plane—they carry these huge loads and then they come off the plane for merchants and they drop their merchandise. They put me right at the back, and the hostess says, "Would you mind letting the human donkeys get off first?" Forgive that expression, but that's what she actually said. I said, "Of course not." God, I felt sorry for them; it was just tough stuff. Eventually the plane is empty and I'm still sitting there and I said, "Can I go now?" And she said "No, no, no, not yet." What's happening here? And finally she says, "Come." I walk out and there is a battalion piping me down and a general, who's my mate, welcoming me to Pakistan. They drive me in a convoy to the

Governor's house and that's where I stayed. He's general of the army. General Khan. That's what travel means. Travel means people: friends, touching, sensing. It's not about just seeing. It's the experience of life. And the one thing you do understand about it is that in the ordinary world, generosity overpowers greed. People are, by their natures, wonderfully generous. And that comes back to that wisdom thing we talked about earlier: be nice, be kind, be joyous, because everybody else will be. They recognize it. That is the original wisdom. That's the world's wisdom, not mine. That's what the world teaches you: that humans have an infinite capacity to be generous. They may be evil, they may be awful in so many respects, but that's always men. Individuals can be evil and the world has got lots of bad men (and some bad women, but mostly men). But, generally speaking, people are generous and kind.

You wake up in the morning and you say, "How did I screw up yesterday, and what can I do today that may be a little bit better?" We are our own paradigm, and if somebody asked me to name one word, other than generosity, that is a part of a necessity to survive, it's "persistence." Never, never give up. Never give up. Never! Life is about climbing a cliff, not about running a race. It's about climbing a very steep cliff, and you're hanging on with your fingernails all the way up and you hear a noise—these are people who have fallen off the cliff. He who hangs on longest wins! It's not about breaking the tape, it's not about a Boys' Own heroism, it's about hanging in and persisting with your principles and your resolve and your ambition. Most of us give up too early. Failure is an absolute essential in life. If we never fail, how could we possibly succeed? We can only extend ourselves to the limit of what we know. Failure teaches us what we don't know. It is essential to fail. You dare your genius to walk the wildest, unknown way. Of course you're going to fall down. Of course you're going to. But it's your way, and when you get to the end you'll know something.

There is no fear. There is only consequence. I've been mugged several times. Once, in New York, after I picked myself up, I said to the guy, "What's the matter?" He said, "Give me your wallet, buddy." And I said, "No." He thumped me again. So I got up, and said, "Hey, what's the problem?" And he said, "My family hasn't eaten for three days." I said, "I've got lots of money. Here, we're going to Woolworths." We went in and I bought them a thousand bucks worth of groceries. That guy went into the address book. Now, I have one sad story to tell. I was mugged in South Africa as I stepped out of the airport four years ago and everything went—my luggage was smashed, everything. The book went. The saddest thing in my life. I lost all my addresses. I had every radio station in South Africa saying, "Look, keep the cheques, keep the money, keep everything. Just return the book."

David Amram

I'm getting my sixth honorary doctorate this May, which is a real honor and a privilege. But I tell people that my non-honorary degree, the one that I actually had to put the academic work into, was as a history major. So with all that I've learned about literature, art, music, symphony composition, writing operas, writing film scores, playing, performing, all of those are part of the greater university which I refer to as the University of Hang-out-ology. Hang-out-ology means being with those who know more than you, trying to be in their company, learning to say please and thank you, and understanding, from a very rudimentary perspective, what it is all about.

I was a struggling classical composer and a jazz French horn player, two guaranteed ways to have a zero non-career or have the ability to do anything except be a schizophrenic nutcase, according to any career counselling at that time. Years later, when I was doing all the things I'd dreamed of doing, I realized it was something I was destined to do.

And when I was a little boy in Pennsylvania, sitting up in our farmhouse in 1937, and hearing that train go from Philadelphia to New York as it passed the railroad station about four miles from our little farm, I'd hear that whistle and I could imagine someday maybe I'd be on a train like that, go to that magical place called New York, and maybe be able to do something in music. And, fortunately, at the age of seventy-seven, as we speak, I still have that thrill every time I leave the house to go to do anything. I still can't believe I'm getting a chance to do it. That was a very fortunate thing, that I was able to have a dream and to have people, all during my life, no matter how impossible it seemed, encourage me to continue to persevere. Whatever I had to do to pay the rent, not to give up, to be the best that I could be, trying to respect others, to learn from others, to share with others, and to keep being creative each and every day. We're all born with that and we lose that very often in the process of trying to figure out what to do to survive.

Miles Davis said there are no wrong notes in jazz. By that he did not mean to play anything—he had the most beautiful selection of notes imaginable. But he meant anything that you have can move to something else if you have a right path. When I was playing with Charles Mingus, I was a twenty-four-year-old hayseed in New York City playing with these giants; I was in the middle of playing my French horn and the cash register went bo-la-la-binka-ding. And I got confused. Mingus said, "Come on, man, don't pay any mind to that cash register." He said, "Next time that happens, play off the cash register." I said, "What?" He said, "Use that as part of the music. If you're playing, the piano player is going blockity-block, the drum is going buckita-bucka-ding. Put that into the music and answer it. Go bita-boo-boo-bum and answer the cash register. Make that part of the whole experience."

Continue to start out every day. Dizzy Gillespie said, "That trumpet is lying in the case every day, waiting for me." Each day you're starting out from the unknown and you're beginning all over again. So one of the ways not to get writer's block or disillusionment or enraged senior-bopperville, is to count your blessings, if you're alive and are blessed to have good health. Part of the job is not only to think about ourselves and what we're doing, but to remember that part of the joy and the health-ification of yourself and the world is to share and put back; like organic farming, something back into that soil.

Giving and sharing and gentility and graciousness are not signs of weakness, they're signs of strength.

Garret FitzGerald

Above all, avoid cynicism.

There are many grounds for cynicism to be found in public life and especially in political life. The temptation to be cynical can be very dangerous indeed. Because if you get cynical about other people, you end up losing your own convictions. Keep an eye on your objectives and don't forget what you are there for. Watch for sycophancy and watch for the temptations of power. Guard against them. Do not get drawn into enjoying the advantages of office as distinct from getting on with doing the job. Family can be very important in that relationship. If you have a family who are constructively critical, they can help you get through all the hazards of politics.

If it's power you want, then it can change you for the worse. If, however, your desire for power has to do with particular objectives for a country, then it needn't have such an adverse effect. If you have power in any form, you are being cut off from other people to some degree. They don't always tell you the truth. You can suffer from sycophancy, which is the most dangerous disease a politician faces. You need people around you who will not be sycophantic, who will tell you what they think, who will stand up to you and argue with you. Otherwise you can easily deteriorate, rapidly.

In politics there's always a question of compromise. If a politician always does the right thing, regardless of consequences, he or she won't survive long. On the other hand, if they do the popular thing all the time, there's no point in them being there. So the nature of politics is compromise. But always with a view to doing enough useful things to justify the compromises you have to undertake in order to stay there and get something useful done. And that is the key to it. I think perhaps people who are not in politics don't understand this issue of compromise. Because politicians must compromise to survive, they are downgraded morally by people outside who don't face these issues. Politics involves a huge increase in the kind of moral dilemmas you meet. In your own life, you meet moral dilemmas, usually more between a greater or lesser good, or a greater or lesser evil. In politics, the number of decisions you have to make which require a moral compass is enlarged, which makes it the most exciting career you can have.

I'd go out of my mind if I weren't working. I usually work from 9.30 a.m. until 10.30 p.m., for, on average, six days a week. If I weren't doing that, I'd be very unhappy indeed. There's nothing to stop you. This idea of retirement is ridiculous. Retirement means that you need less sleep. Two hours less sleep. Therefore you can increase your productivity by perhaps fifteen percent. But that's not widely understood.

Helmut Jahn

I've always been involved in sports. The first thing you start doing in sports when you travel a lot is running; and swimming. And when I got into a position where I could afford it, I bought a boat. And I have probably my seventh or eighth boat. And we do it in a very professional way—we race, and it requires a lot of discipline. I also started bicycling. Physical fitness makes me feel better. If I can't do one of those things every day, then I don't have a good day, I don't feel right. I have to do something. I go running in the morning, I go swimming at night. Every day. And every weekend I bicycle about forty to forty-five miles, Saturday to Sunday; out in the country. I tore my ACL skiing, and I haven't had time to get it fixed, so I wear a brace when I sail, ski, and run.

I don't have to work any more. A lot of people don't *want* to work any more, because they don't like to work. I don't *have* to work, but I *like* to work, and only when you like to work can you actually do good things. Perfecting a design is a process which is only constrained by the limits of time: you have to go through the various phases, et cetera. That's why I always prefer jobs that go fast because otherwise you agonize too much. When you design a car you build thousands, hundreds of thousands, a million of them. Millions of products, computers, iPhones,

whatever. But a building, you only do one. That's what makes it exciting. That's why I can't stop.

First of all, it's important to realize the limitations of what you are and what you can do. Are you a designer? Are you more into execution? Look ahead, and think: no limits, everything is possible. Secondly, you have to have optimism that things can be done—and this is very important with your client. You have to actually bring your client along, so that he carries that same belief, so that your vision can be realized. Thirdly, you must have courage. You have to go to the limit. And courage can get you into a very dangerous situation. For example, my coach took me on a bicycle ride in Sardinia going down a mountain at forty-seven miles an hour. I'd never done this, and he says, "You gotta put your foot on the bicycle, otherwise it starts to vibrate!" Danger is something you can master if you actually know what can happen. Because courage without preparation—that's when people die out in the water. So you have the extreme knowledge—when you go to the limit in designing a building that is very high or is very wide. And, finally, you have to collaborate in a team. In a team, each individual becomes stronger. I'm not just giving this advice to young architects, I'm giving this advice to old architects and to everyone.

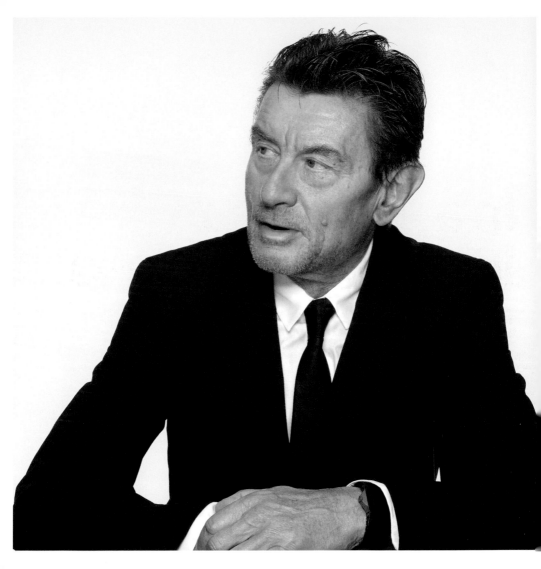

In a team, each individual becomes stronger.

Robert Redford

Once you start thinking about financial security, you're beginning to run the risk of eroding your true self as an artist. Once you start thinking about money, once you start thinking about security, I'm not sure you're going to be able to take the risks you need to take. You want to stay clear of that; let that part, hopefully, take care of itself.

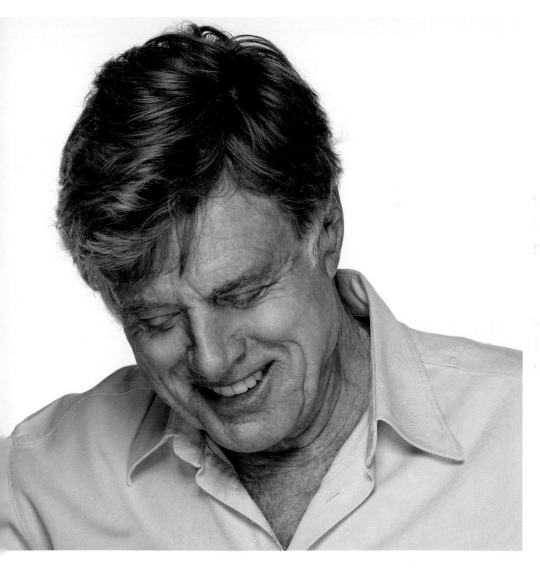

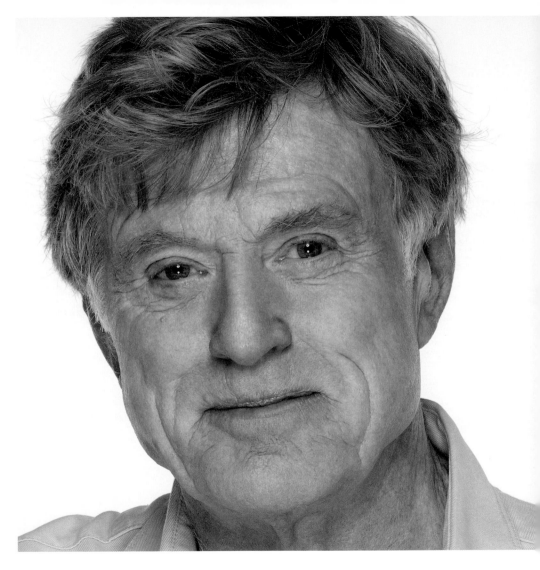

I just can't stop working. Nothing excites me more than being inspired by a new creative idea. It's all part of being an artist. I get excited about ideas, and then I get excited about wanting to execute them, put it into action. I can't seem to control that, and that keeps me going. I don't spend a lot of time looking back, either. I do take into consideration failures and why they occurred, or painful moments; I don't believe in ignoring that stuff. But I also don't like spending a lot of time on successes of the past. I just don't. So I'm pretty much always looking forward: what's next, what new thing can I do?

Independence allows you to remain true to yourself as an artist. Whatever your spiritual impulses are as an artist—who you are—it's easier to maintain that with independence.

Chuck Close

Now that my children are grown and in another house, I work essentially three hundred and sixty-five days of the year. I work Christmas Eve, Christmas Day, New Year's Eve, New Year's Day—doesn't make any difference. Any day that you just do a little something, all those little pieces of something add up and it continues the momentum. You don't sit in the studio after not having been in there for several days, thinking, "Oh my God, now what was I doing, where was I, what's happening?" It's really, really important to keep continuity and keep momentum going. It's got to be true in many professions. But in a lot of professions, they're waiting for Friday. They can't wait for Friday, and then they try to make up over the weekend for how numbingly boring their life is all week long. So they approach the weekend with a kind of desperation, like I've got to have fun and I have to mitigate for how awful the week has been and I better have some toys: I better have a BMW convertible, I better have a boat, I better have all these other things. And then with this kind of desperate search for pleasure they try to cram it all in to Saturday and Sunday and then go back to the workplace on the following Monday. I just can't conceive of living that way. It just seems so unbelievably crazy to me. When I was working in Bridgehampton, when Labor Day rolled around I'd watch all the husbands get in their cars and drive back to the city, and I was out there in the country with all of the women, and I thought, well, now who's a schmuck to become an artist? I get to stay here, I get to go to the beach, I get to paint, I get to do all these wonderful things, and all you guys have crawled into your Mercedes and BMWs, all sitting on the highway like lemmings to the sea, slowly making your way back to the grind. There wasn't going to be anything in the way of remuneration that was going to make up for leading a life that didn't have pleasure as an everyday part of the activity. It's an incredible indictment of the capitalist system: we are free to pick and choose the careers we want to have, we don't have to work for the state, we don't have to work on a collective farm, if you are an artist you don't have to make propaganda that supports the government, we're free to find something that we enjoy doing that also will bring us enough financial remuneration to allow us to continue to live. And upwards of eighty percent of the public say they get no pleasure whatsoever from what they do for a living. And that's most of their life. It just seems crazy.

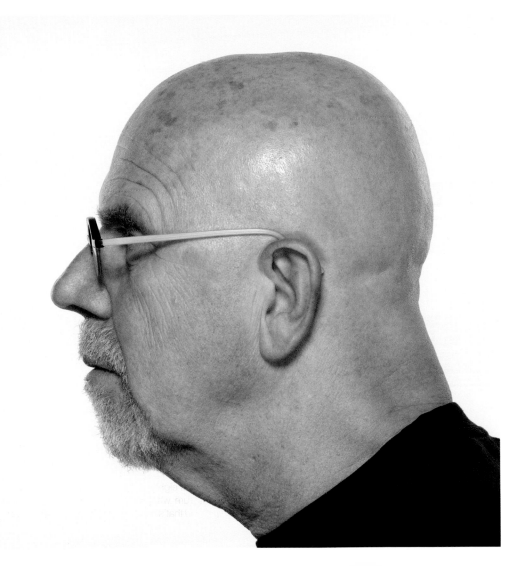

Dave Brubeck

If you don't love music, almost next to family, if you don't love it enough to want it regardless of what it does to you, don't get into it. Because it's going to demand much of you and of your family. If by doing music you have a great feeling of joy and you'll accept all the hardship and your family accepts it, if it's the drive in your life and the beauty of expression in your life, then do it and know that it's going to be very difficult, but the love will make up for all the hardship.

Nadine Gordimer

Writing is a discovery.

Juan José Linz

Be curious; be interested in the world. Your satisfaction is in what you know. Before you started reading something or writing or doing your research or doing some interviews or analyzing some survey data, you didn't know something, and at the end of the day, you got to know something you didn't know before and that other people didn't know before, that you can communicate to other people. The creation of knowledge is a great satisfaction.

If you go into academia, do not be completely bound by the fads of the time, the dominant theories or the dominant methodologies. The fundamental thing for a student in any of the social sciences particularly, but in any field, is to be curious, to be passionate about getting to know more.

Wisdom is a mixture of three basic things. One, a certain amount of knowledge. I mean, it doesn't need to be specific, professional, technical knowledge—but knowledge. You cannot be totally ignorant and be wise. Two, people then need to use that knowledge and reason about the implications of knowledge. What can you do with it? And three, responsibility. You must think of what your knowledge is going to be used for and what you want to use it for. There are some people who are very intelligent, very knowledgeable, but whose ideas and thinking is not for, for the good of anyone or anything other than their own self satisfaction or their own ambition. They are not wise people. So I think it's a combination of knowledge, reason, and responsibility.

The creation of knowledge is a great satisfaction.

Yoko Ono

It's very important that now we start to think about our soul, our spirit. And when I say "soul" it has nothing to do with religions. Just our soul. We have a soul and a spirit. And we should start thinking about that instead of monetary gain. The common truth is that we are people and we should be proud of the fact that we're human beings. We should appreciate what we have. Our body's structure is incredible, how it works. It's like a miracle. Every day I think that we are a race of miracles. Be yourself, love yourself, and give that love to the world.

Malcolm Fraser

Wisdom is a rare commodity. There are a lot of very brilliant people, bright people, clever people; not so many people who are wise. I'm not sure I can define wisdom in any clear, short way that's going to make a great deal of sense. But once you've known somebody for a while, you'll begin to understand whether they're wise or not. Of all the people I've met anywhere in the world, I think the wisest and the best person was Mandela: somebody who could endure what he endured over the best part of three decades, come out of that with no sense of bitterness, no sense of sourness, who made friends with his jailers, recognized the other fellow's point of view, realized you can't come to a solution unless the point of view of the person to whom you're sometimes very strongly opposed is also taken into account. The man's charity, his humanity…he may be the living definition of wisdom. There is an innate dignity about Mandela. He embraces a sense of decency, a sense of compassion, a sense of concern. Never a complaint about the way he'd been treated, always looking to the future. I don't really know how to define dignity, but you know if somebody is dignified or not. Mandela is so far ahead of the rest of the human race. He's an example that I would like to think more people could follow. If part of his life could be made compulsory in all school curriculum programs, it would be a very good thing, because apart from Christ or the leaders of the great religions, I don't know where you go. He is a humble man; in no way bombastic. Holds his views strongly; will express them fearlessly.

It is what we make out of what we have, not what we are given, that separates one person from another.

There is this figure called Madeleine Albright and then there's me. And Madeleine Albright is somebody that I think has done a lot for breaking the glass ceiling. But my kids and my grandchildren react to me.

Buzz Aldrin

If we keep looking only at where our feet are going, we may walk off the cliff. We may miss a great opportunity. But if we can look up and look ahead, look forward, there's a greater chance that we'll live more productive lives.

I feel very honored to have been in the right place at the right time and to have lived up to the expectations I think other people have had of me. To deal with shortcomings, to learn how to appropriately look for help, to help other people as they are helping you— it all works out in a very smooth way, where we're not antagonizing other people. I try to be of service as much as I can. I feel that there is an obligation. I'm very proud of my country and I'm proud to be able to serve it. I'm not trying to be all things to all people. Wherever my talents are, I will use them to the most for the benefit of the future as I see it.

Jane Goodall

The very most important thing that we can do to try and get out of the mess we've made on this planet, both social and environmental, is to spend a little bit of time learning and thinking about the consequences of the choices we make each day. What did we eat? How was it grown? Where did it come from? Did it affect the environment adversely, or animal welfare? Is it good for human health? What do we wear? Where was it made? Does this involve child slave-labor or sweatshops? How do we get from A to B? Could we do it in a way that is less damaging to the environment? If we start to think like that, inevitably people make small changes, because very often they do things without having the faintest idea of the adverse consequences, and if people start making the small changes, then you start getting the major change that we must have if we care about the future for our children.

Edward M. Kennedy

You don't have to be a United States senator to make a difference. Nurses make a difference. Policemen make a difference. People who work with special needs children make a difference. Those are the positive forces in our life that make life worthwhile and worth living.

I find that each day, each day, I can make some small difference in people's lives. And as long as I feel that I can, I'm going to stay in the United States Senate. I'm going to stay there—until I get the hang of it.

For a career in public service, you have to work and develop knowledge about what you're most concerned about, what motivates you. You have to learn, and study, and work hard on that. That's enormously important. And then you have to try and work locally, try to make a difference in local communities. It may be in government, it may be in a non-profit, it may be in some other kind of organization. But working at the local level and meeting and working with people who are inspirational, in and of themselves, inspires you to work hard and to continue the pathway to a public life. I was able to take a shortcut because of the relationship with my brothers, but I worked hard in their campaigns and enjoy working hard. Every day I worked with them I was always inspired: they were making a difference and I could make a difference.

Federico Mayor Zaragoza

The path toward peace is much easier than the path toward war and confrontation.

The path toward peace is much easier than the path toward war and confrontation. We have a lot of good examples, but let me choose one. In June 1963, just some months before President Kennedy was assassinated, he said, "I am told that disarmament is impossible. It's not true. I am told that peace is unfeasible. It's not true. There is no challenge that is beyond the human creative capacity." This is what I think. This is what I considered when I was in UNESCO. We have the capacity to create, to invent. This is the monument that we must safeguard. Solutions are easier than we can imagine; because what we must do is to listen. What we must do is to create a permanent dialogue. And we must accept all views, all opinions. Sometimes I have spoken with leaders that are little dictators or very big dictators, and they say, "Yes, but provided that those that are in the dialogue say exactly what I would like." No, no, no. You must accept that one or two or three or many people in one dialogue may have an opinion that is exactly opposite to yours. And you must accept all. Only one thing is unacceptable: lying. All the citizens of the world have seen that the leaders of the world, unfortunately, were lying because they wanted war. They wanted to invade Iraq and they were lying. We must put that aside. The way toward peace is easier than we can imagine, provided that we are able to invent peace, that we are able to behave according to our reflection. Very often we are spectators of what happens. We are resigned spectators. We are there only as receptors. And we must be actors of our lives. This is the most important mission you can have in the world.

Education is not information, it's not instruction, it's not training. It's much more than this. It's to behave according to our own reflection. When I was Director-General of UNESCO, I requested the President of the European Commission, Mr. Jacques Delores, to chair a world commission on education in the twenty-first century. And a very short summary of what they suggested us to do is: learn to know, learn to do, and learn to be. If you know, you can do. Learn to be yourself. And learn to live all together.

Rupert Neudeck

I was always aware of this: don't ask the experts.

In my life, in my activities, I was becoming aware of the very ambiguous position of prudence and intelligence—especially of academic and professional intelligence. Expertise; experts; knowledge. If we always follow academic knowledge and professional knowledge, we will never arrive at the idea of going into the sea to save people. There are many arguments against it, many very good arguments: it's too risky; the sea law jurisdiction is not defined; we are going into an area controlled by the Vietnamese Navy; we have to go into an area where there are pirates. It's dangerous. All arguments are against this activity. But then there is the question of whether you will do it. This is quite another question. That has nothing to do with experts. It has nothing to do with so-called competent people.

I was always aware of this: don't ask the experts. My government asked me whether I had asked the "competent" organization for what I wanted to do. Thirty years ago, I didn't know that there was an organization, but there was one. Everywhere in the world we have "competent" organizations. In Geneva, there was a United Nations High Commissioner for Refugees, and I went there. This man was "competent" for my request. And after I attacked him, when I wrote, "Are you doing anything? You have the competence as a world organization under the umbrella of the United Nations. What are you doing there?" he told me, "No, this is very, very difficult. We haven't yet taken up this case, and we

can't go beyond the border to the other side to interview the refugees. How should we do it, interview people on the sea? We cannot put a table there!" That was before I knew that non-governmental activities go straight to the problems of people in distress, rather than to the "competent" people.

A single person can convince a whole society. As a single person on the train from Paris to Cologne, on 3 February 1979, I was looking around myself, thinking, how could I convince my society? I wrote then to Heinrich Böll, who was known in our society, who was popular—I wrote him a letter on the train. Two days later he phoned me, and said, "Yes, Neudeck, we have to do this. We have to do it together. I will do it with you." So this was two. One becomes two, and then it grows. Anyone can do something important to mankind. You never have to be limited by being alone. That's just your imagination. You're always bonded to others—in your profession, in your family, in your hometown, in the train, in the plane, wherever. We are living in a quite exciting time because it's easier now to work with others and to convince and to inform others. Anyone has the Internet now. You can make your own newspaper if you like. You, that single person. Possibility is bigger than reality.

Traditionally, we grow up to learn that we should be ordinary citizens who would like to have a career. This is a limitation in itself. A career is good,

but if it is the only thing you are looking forward to, then it is bad. There's a big obstacle in ourselves because of the conditions of life, of the framework of our society. Obstacle number one is insurance. If you are always looking for security in money, then you are in a very bad situation. The framework of a good society, of a wealthy society, is sometimes a hindrance for doing something for others. That is not an argument against wealth and against a good society and against security. We should use these things, and we should be happy if we can help others, for the future of our children, for the whole world, and all mankind.

I can't think of an activity I've had to do alone. You have to live bonded to others. When my wife and I got married and when we had our first child, we were not aware of the work I was about to do. It happened suddenly. But we felt that the humanitarian work supported our life as a couple. Women, in a society like ours, feel underestimated when they only take care of their children and don't keep their jobs. And my wife decided to leave her job for the children when they were growing up. But then we were in this position where she could do the same full-time job inside our organization, and she could do it with the children, who were always with us. I always thought of that as a model for a normal society like ours, that people can do a lot being together when they are pushing together, putting all their energies together synergistically toward work.

Jacques Pépin

Lévi-Strauss said the process of cooking is a process by which nature is transforming into culture, and for me it's still just about the best definition. Ever since fire was invented, so many centuries have added things to that fire: tradition, ritual, habit. To hold that body of ritual and tradition, which is brewed in with the food, makes it so that having dinner together around the table may be the best expression of what civilization is.

Billie Jean King

Tennis taught me so many lessons in life. One of the things it taught me is that every ball that comes to me, I have to make a decision. I have to accept responsibility for the consequences every time I hit a ball. It also taught me about delayed gratification. No matter how you look or how much money you have, you still have to learn your craft, you have to hit a lot of balls, you have to train. There's disciplines of life that you learn from tennis or other sports. Another thing is that you learn to adapt. I have these two sayings, "Champions adjust," and, "Pressure is a privilege." Tennis teaches you about those things. When you're playing a tennis match, you can't say, "Stop, I want to do another take," or, "Can I play that over?" That's the way sports are. They're very real that way. So they teach you lessons in life, but the most important one is accepting responsibility. You have to make a decision, live with the consequence. That's what tennis does with every ball that comes to me, and I just use my experience in tennis in everyday life now and it's fabulous. It's been a great journey to learn those lessons.

At the dinner table, I probably got the best advice from my mom and dad; and when you're young you don't think they're very smart, but as you get older and older you realize, "Oh my gosh, they were right." My mom always said to be true to yourself. "To thine own self be true,"—Shakespeare's saying. That has been very important to me, especially going through the struggles I've had with my sexuality; that was my hardest struggle, to come to grips with that; and also get my family, who were very homophobic, to accept it. And they have, and everything's great now. One of my goals was to be at peace with my mom and my dad and my brother. My brother was always great about it, but it was a hard, hard, hard struggle for many, many years. I was very shame-based, and when you get shame-based you get very quiet. I was paralyzed. That was a long journey for me. "To thine own self be true." And bring all of yourself to whatever you do in your life. If it even means meditating and letting go, it's still all of you—just live and embrace the moment.

I was in the air force a while and they had what they call "policing the area." That's where you looked around and if there's anything wrong here, there, anywhere, you took care of your own area. And I think that's a pretty good thing to go by. If everyone just takes care of their own area then we won't have any problems. Be here. Be present. Wherever you are, be there. And look around you and see what needs to be changed.

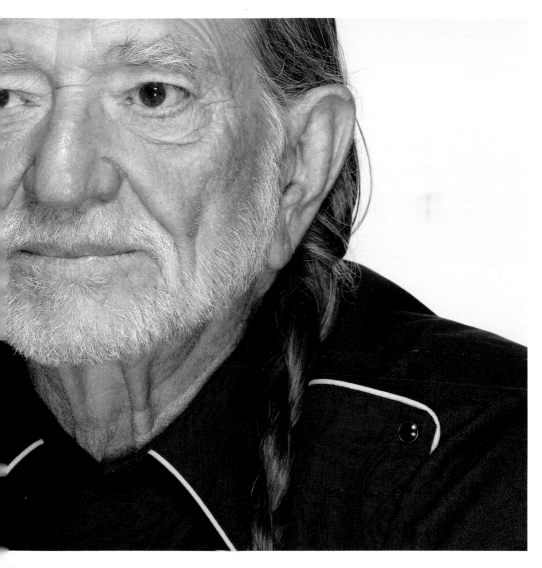

Wole Soyinka

Be yourself. Ultimately, just be yourself.

When you take culture away from a society, the effect that I hope it has is rebellion, because you're depriving the people of their humanity, and it means they're degraded, they are considered subhuman. Culture is the outstanding difference between *Homo sapiens* and most of the animal world (although there are some animals which seem to have greater culture than human beings sometimes).

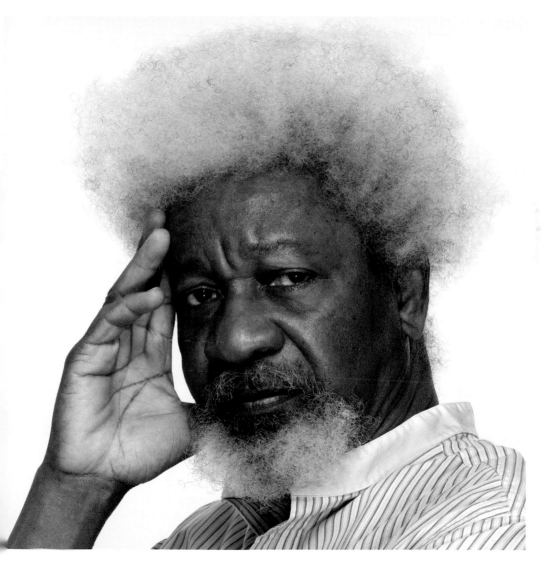

If a person is confident enough in the way they feel, whether it's an art form or whether it's just in life, it comes off—you don't have anything to prove; you can just be what you are.

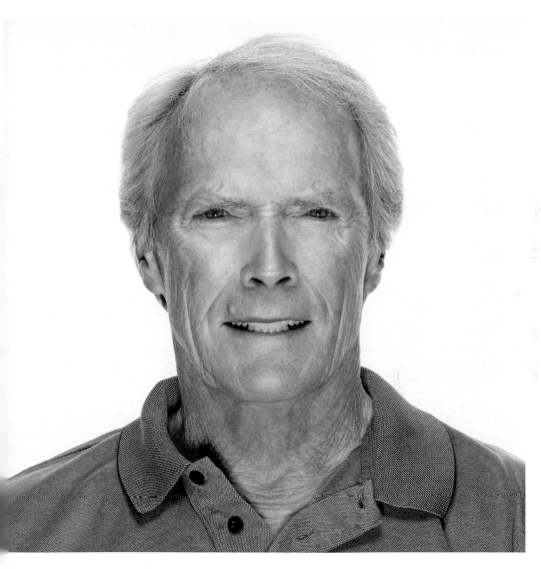

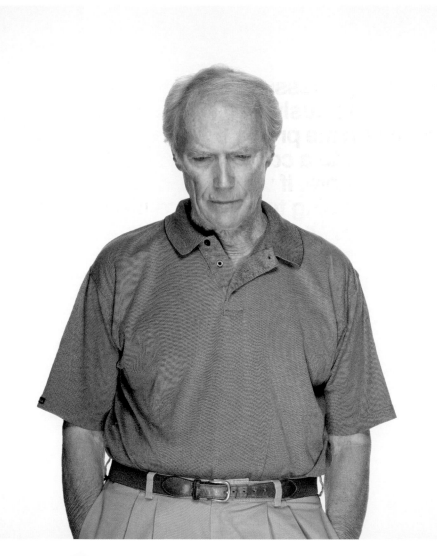

Take your profession seriously; don't take yourself seriously. Don't take yourself seriously in the process, because you really only matter to a certain degree in the whole circus out here. If you take yourself seriously you're not going to be able to move forward and use your best artistic instincts. You're going to be hampered by always wanting to look in the mirror and see if you have enough tuna oil on your hair or something like that.

Bernice Johnson Reagon

Don't take yourself seriously. Don't take yourself so seriously. It is easy—when I was working at the Smithsonian I was always working with elders and I started in my thirties and forties, and I was really struck with how easy it was for them to say or do whatever they wanted, and I remember thinking, when I get eighty I'm going to find a forty-year-old, somebody, and drive them crazy because I'm not going to have any checks, and say, "Well, how am I going to say this so that he or she is going to understand it?" It's just like, by the time you hit a certain point, you just say, "This is who I am, this is what I can give and hopefully it will be of some use, if not, throw it away."

Since I was a child, my mother told us that we had souls and that we had bodies; because we had bodies they would die but the soul goes on forever. That was hard for me to deal with as a child: I couldn't figure out how this worked to have both of those things. Then one day she told me that you're responsible for the condition of your soul, in charge of something that was a part of *the never-ending* and then that you could mess *it* up. And I think because I couldn't deal with it as a child, I actually held it and eventually got very comfortable with it. So, with my music there is always a joining of that which is channeled and that which is intellectually created; and I'm a singer, and so my body is always powerfully engaged in creating the music. It's this nice partnership.

Burt Bacharach

I have notes in my bathroom, yellow notes, and I stick 'em on the mirror, things that happened that were uplifting boosters for me. Notes that say, "Today is special, make today count." And then I have one note on the mirror in the middle that says, "Look at the other notes."

People say, "You're very good for your age." And I say, "I haven't got time to grow old. I just don't have time. Far too busy."

It's good for the children if you have an occupation that isn't just ironing and washing and cooking—which I've done all my life, I'm not decrying it—but you're a more interesting person to your children if you bring interesting people home, you go away and meet interesting people, you come back and tell people about it. It's a whole new side to a child's upbringing.

All the old gentlemen who live to be an enormous age and still produce children are all very creative men, aren't they? Picasso, and great writers, and Augustus John who then went on living life to the full and having love affairs…it very much has something to do with the fact of this hugely strong creative impulse, and I know that I am able to do things that girls of my age—women of my age—haven't done for ages. I still walk a long way every day with my dogs. I'm out an awful lot, all through the day. When we go anywhere I drive the car. I'm sure that has a lot to do with the fact that I haven't fallen by the wayside or gone gaga or stuck in a bed somewhere.

We had a lovely actress called Thora Hird, who was a North Country woman. She was a wonderful actress. She did end up in a wheelchair, I think, but she was well into her nineties and she was still acting. Someone said to her, "You're marvelous, Thora." And she said, "You don't stop doing things because you get old. You get old because you stop doing things." It's simplistic but it is true.

My father was in the navy, and he was stationed in Cardiff in South Wales, which is a big dock area for Atlantic convoys, and we had about ten days or two weeks of intensive bombing, night after night after night. We lived in a block of flats, and we were really okay. I think that was the nearest I ever came to being in a sort of bad situation, but nobody bothered really too much about it. You got out in the morning and you were all filthy dirty, and I had to go to school. You'd walk out and there were no windows in any of the shops, and half of the houses had been burnt because they'd dropped incendiary bombs. But you just carried on. It was a bit scary when it was a lovely clear moon, because you always knew that was going to be a bombing night. The wonderful thing about the war, of course, was that you met hundreds of people, characters, personalities; different people from every walk of life, whom one would never have met if there hadn't been a war. There was a certain glamor about it all. I look back on it as a time of rather tiresome deprivation, like not being able to buy silk stockings and not being able to find hairgrips and having to pull the blackout—all these sort of little trivial things were far more annoying than being bombed or that sort of thing. And there was a wonderful atmosphere of complete resolution and confidence, which is awfully difficult to describe to your children.

You're traveling on a liner and you're traveling cheap, and you look down on the first-class people all having a marvelous time, having drinks and the rest of it, and you think, "Gosh, here I am stuck on this horrible little deck." But if you fall overboard, that deck would look like heaven, wouldn't it? It's entirely point of view; perspective.

You can't get to "wonderful" without passing through "all right." And when you get to "all right," you should look around and familiarize yourself with things, because that may be what you are capable of. And that's all right.

There's a tendency to build a mold and then expect a kid to go fit himself in it. But people have different abilities and different tolerances. My grandmother was the biggest influence on me, insofar as my opinion of myself. When everybody said, "Billy stutters and he's never gonna grow," my grandmother would say, "Billy's cool. Maybe he's got something that you guys don't see." My grandmother always let me know that it was okay to be me, and that I might have something about me that may be a little bit different, that if I figured it out, I could apply it in some way to be okay. You know I'm a big fan of "all right." You can't get to "wonderful" without passing through "all right." And when you get to "all right," you should look around and familiarize yourself with things, because that may be what you are capable of. And that's all right.

Excess is predicated on access. My daughter used to dream, "I'm the empress of the world." We all dream big. But if you take a bunch of kids that have been kept out of the loop, when they get access, they deal in excess. You would hope that somewhere along the way, they would realize it's just not a good use of money to go buy a bunch of platinum and put it in their mouths. There are smarter things to do. It's just not smart money-handling. I am a

functional kind of guy. I'm not interested in showing excess. I am interested in the preservation of whatever modest wealth that I might have accumulated. But then that's a function of being smart. And part of that is the drudgery of trying to understand what is prudent to do with whatever money you're making. If you are not into that kind of drudgery, or if you look at it as drudgery, then, of course, you want to announce your presence. So one way to announce your presence is a bunch of gold and something shiny. "Everybody, look, here I come." That's just not my personality.

When you talk about the well-being of a group of people, the concern is what's going to happen to Joe Blow? Joe is cool, man. Right now, what scares me is this matriarchal dependency, the responsibility of women. So many people's survival is dependent on how responsible the women are in their lives. More often than need be, it's grandmothers. Something ain't fat right in the center: some regular guys that you can depend on. That's why I'm not in love with this pimp terminology. I never found it amusing that "pimping" is such a lovable term. It's a little bit embarrassing. It bothers me that not enough guys know how to fix things in the house. How useful are you? Other than just, "I am, therefore I am wonderful"?

If I knew where wisdom came from, I would move there. That's where I would live. No, wisdom comes from a lot of stuff. Education is a factor, but who was it that said that education is the sum total of what you know, not necessarily where you got it from? Education would encompass everything from tying your shoes to doing your taxes. Everything.

Dignity is the operative word. There are people who make confessions: I have sinned, I have done this and I have done that. Whatever I've done, I'm not that interested in laying it out there. Whatever's wrong with me, if I can keep you from finding that out, I will. And whatever's right with me should manifest itself in some deed.

If you think of wisdom as this big pot that people have been putting stuff in for thousands of years—somebody invented a safety pin and threw that in the pot; Dr Phil and Oprah, they're putting their stuff in the pot; the Chinese came up with spaghetti a long time ago and put that in the pot; when I was a kid somebody put the Salk vaccine in the pot to ward off polio; maybe during your lifetime somebody will put an HIV vaccination in the pot; and then somebody puts music in the pot and they put theater in the pot; there's all this stuff that goes in the pot. And it's probably equal parts optimists and equal parts pessimists.

We are all accidents of birth. We don't get to choose what we look like, we don't get to choose how gifted we're going to be, how tall, how strong. We don't get to choose anything. One day, somebody says, "You are. Now, this is your name. Look in the mirror, that's what you look like. This is your Aunt Suzy, this is your toe, this is your elbow." Don't play with that! Try to do what you can with that. And you may happen to find yourself in a lineage that is educated. Congratulations. You may also be born in a crack house. You didn't make that choice. Some of the dumbest things, some of the things you would like to apologize for when you were a kid: making fun of somebody's looks. Like somebody says, "You know what, I think I will just be as ugly as I can. I think I will be crippled. I think I will be genetically predisposed to gain weight." The only choice we really have is to be us. Some of the most frustrating lives are people who can't come to grips with who they are. So eventually you are either going to come to grips with who you are or you are going to be a little bit nuts, or in a constant state of frustration with yourself. Constant states of frustration are hard enough to avoid anyway, without helping it out any.

Jimmy Little

The wisdom is forever there in our faith; in our understanding of Mother Nature and Father Time.

Wisdom came naturally to me. I didn't question it as a boy, being the eldest with all my siblings and growing up, with Mom and Dad as two bookends, figures, role models. We all had this wonderful oral history—passing on of our history, our culture and of our beliefs. Mom and Dad didn't strictly sit us down to a schooling of, "This is right, that's wrong, this is okay." It was kind of bred naturally. You'd go to camps, like the other neighbors who were all camping in one big area, and everybody acted the same and did the same; so there was a similarity right across the board of respect, grace, faith. All of this amounted to wisdom to us. The children were taken by the mothers and by the fathers in different paths of learning: this is what you eat, this is the bush medicine, this is the bush tucker, and this is a no-no—all those things were so natural that we just didn't question it, we just went along with it. But at the same time, by the same token, in my case Mom and Dad and their parents gave us signs that we wouldn't need all the indigenous Aboriginal teaching, because we were moving into another era, another lifestyle, another dimension.

So we have to have room to do a translation, to transfer the skills into modern living, because they knew from their wisdom that we were going to grow up in a multicultural environment and not just an Aboriginal environment. In the colonization of the nation there was this awareness, "Oh yeah, there's new people around." This is what my mom and dad were saying, and my grandparents: "You've got to be wise. You've got to be honest. You've got to be sincere. You've got to be true to yourself." Imagine a big quilt—a pattern of life that we would have to live under. We were taught that the horizon, the ceiling, and the floor of our region, of our territory, was our supermarket; it was our place of worship, our church; it was our recreational center; it was our craft room for making artifacts, painting, and boomerangs.

I'm painting the pretty side, but also there's been cruelty in my life. My father's father's father was hiding in a hollow log in Queensland from the troopers and the settlers who used to massacre us as a people, chase us off the land; and this is

another story. As it unfolds, it's how you live your life, not trying to live your parents' and grandparents' life, but accepting their warning, their training, and their preparation for you to learn. That's what I've been doing with my daughter and my grandson, preparing them for the modern world from my old-fashioned world. The wisdom is forever there in our faith; in our understanding of Mother Nature and Father Time; our understanding of the food chain, blossoming season to season; our understanding of the bush medicine. I'm painting you a peaceful picture, but it was still hard work to work out with Mother Nature if you got too much rain or not enough, and not enough fish and not enough kangaroos.

My dad told me, "Son, there are three words that will open any door: the door of a building, the door of the mind, the door of the heart, any door you like. Three words, don't forget, always use them. 'Thank you' and 'please.' That's your calling card." So we learnt to respect the land and each other, and respect what a person can share and give.

The importance of teaching goes back again to my early learning, that as part of the journey, the ride, you pay a ticket for the journey. In paying for the journey, every day I want to help somebody. With a word on the telephone, with a note, with a fax, saying hello to somebody—I enjoy putting a smile on people's faces. If I touch a life with a word then that's part of me saying, "Thank you, Lord, for giving me this day of inspiring others to lift their chin up." This day will be over with, another day's coming; just enjoy one day at a time. I just like to inspire people to enjoy life to the full. I told my grandson the other day, "Son, I'm showing you around all your tribal area." I took him down to where my grandparents were buried on the mission and I said, "You've got a lot of blood and genes here in this ground—sacred ground. While I'm telling you all this, don't think that you have to live their lives. They lived their lives. Life starts with you, not with me, your grandfather, not with your mom. We have a hand in your life, but from your life all the way through it's your life to live the way you want it. Just treat it with respect."

Esther Mahlangu

When I grew up, I learned that you must respect the elders. You were supposed to understand that you are young, and the elders were supposed to give you the relevant rules and regulations.

Mary Quant

Risk it, go for it. Life always gives you another chance, another go at it. It's very important to take enormous risks.

Václav Havel

No human community can exist without culture.

Prison taught me a number of things. First of all, I began to appreciate better what human dignity is and what human dignity means. Even in the most difficult circumstances one can retain one's decency and dignity. Secondly, it was a major school of discipline and self-control. I could see around me many beefy inmates who showed off to the people around them, but ultimately they were incapable of controlling even themselves, and they were embarrassing. Thirdly, it was important not to lord it over others. I was there for political reasons; others had committed crimes. But if we wanted to get along somehow, it was necessary not to lie, to accept each other as human beings and not lord it over others.

Culture reflects the emancipation of the human spirit and a striving to understand human existence. Were we to find ourselves at the imaginary beginnings of humankind, I am sure that the first thing to be created would be culture. What form it would assume is another matter.

Apart from what is intrinsic to all living beings, the most fundamental human needs are freedom and the search for the meaning of our existence, of everything that surrounds us and which we are part of.

Kurt Masur

My father told me, "I don't want you to compromise, but be careful. It's your life you are living and nobody else's. Find out who you are and find out what you really believe in." At that time, young boys at the age of fourteen, fifteen, are shaky already, and not knowing where to go. And I got this incredible advice, to watch out very carefully and find out where I feel myself attracted and where I feel myself uncomfortable. I think this is what we can call on to approach wisdom: that your experiences of bad things, of good things, of your own mistakes, of your shame...if you have built up knowledge about yourself, you get to have not only dreams, but visions.

Music can help. Music can help you survive the worst things, things you never could imagine before. No conductor is greater than the great composers have been. We are servants. Of course, we should be servants with all our passion. We give the music our stamp. But if you feel that your stamp is more important than the composition, you fail.

When I started as a young conductor, people liked me because I was very friendly. Then, I remember, one of the orchestra musicians who later became my very good friend, came to me and said, "Dear friend, as a conductor, you behave very badly. If we are not playing good enough, you cannot smile. You're always happy. What's the matter?" Then I learned, step-by-step, what musicians expect from a conductor. They expect honesty. In the arts, you cannot lie. You cannot do a kind of diplomatic thing. If I speak to a musician in the orchestra, he should feel that I respect him highly. Otherwise, he wouldn't be willing to follow me. He must feel like a partner.

Ravi Shankar

I never try to impart wisdom, because I feel I don't have much, really.

But I do love to share passion, love, and ecstasy through my music. All this talk of peace and love, which is a very important thing and which everybody is trying to impart through very intelligent explanations, I can only express through music. I find it so much simpler. It flows out of me.

Death is the necessary precondition for evolution. If you look into the development of life on our planet, you can see how the change of generations is important for the future adaptation to new environmental conditions. In that sense it's very important that we have a limited life span.

Andrew Wyeth

Believe in yourself and believe in love. Love something.

Biographies

Chinua Achebe
16 November 1930
Ogidi, Gongola
Nigeria

Educated at the University of Ibadan, Chinua Achebe began his career with the Nigerian Broadcasting Corporation in 1954. In 1958 he published his first novel, *Things Fall Apart,* which was subsequently translated into over forty languages with sales in excess of eight million copies. With his focus on the clash between traditional culture and Western values, Achebe has become a major voice for African literature. He has written novels, poetry, short stories, children's books, and essay collections. Achebe was awarded the Commonwealth Poetry Prize in 1972 and the Man Booker International Prize for Fiction in 2007.

Madeleine Albright
15 May 1937
Prague
Czech Republic

Madeleine Albright's family fled Nazi persecution in 1939, first to England and then to the USA, where she earned several degrees in international affairs, including a Ph.D. Albright worked on the Muskie presidential campaign in 1972, and later became a staff member of both the National Security Council and the White House. During the Republican administrations of the 1980s and early 1990s she lectured in international affairs at Georgetown University. In 1992, President Clinton appointed her UN Ambassador and five years later she became the first female US Secretary of State (1997–2001). She is a co-founder of the Center for National Policy.

Buzz Aldrin
20 January 1930
Montclair, New Jersey
USA

Buzz Aldrin graduated from West Point Military Academy and served in Korea and Germany as a jet fighter pilot. He received his doctorate in astronautics from the Massachusetts Institute of Technology, and was chosen by NASA to join the astronaut corps in 1963. Buzz and Neil Armstrong became the first two men to set foot on the moon on 20 July 1969 during the Apollo 11 mission. Upon his return, Aldrin received many awards from countries worldwide, including the US Presidential Medal of Freedom. He has authored six books, with the seventh to be published in 2009. He travels and lectures throughout the world (with his wife of twenty years, Lois Driggs Aldrin, a Stanford alumna) sharing his latest ideas for exploring the universe.

David Amram
17 November 1930
Philadelphia, Pennsylvania
USA

David Amram, a virtuoso musician on piano, French horn, and flute, as well as a variety of folk instruments, studied at the Oberlin Conservatory of Music and George Washington University, performed with the National Symphony whilst still a student, and was the first composer-in-residence with the New York Philharmonic in 1966–1967. He has composed more than one hundred works, including two operas and the scores for many films—*The Manchurian Candidate* and *Pull My Daisy,* a collaboration with Jack Kerouac—among them. He continues to perform as a guest conductor for orchestras around the world, and tours regularly with his own quartet.

Alan Arkin
26 March 1934
New York, New York
USA

Alan Arkin formed the folk group The Tarriers after dropping out of college, and co-wrote "The Banana Boat Song," which would later become a hit for Harry Belafonte. His screen debut came in 1957, followed by roles on and off Broadway, and he won a Tony Award in 1963 for *Enter Laughing*. Arkin's role in *The Russians Are Coming* earned him the first of three Academy Award nominations. In 2006 Arkin won an Academy Award for his role in the film *Little Miss Sunshine.* He has written numerous songs, as well as science fiction and children's books.

Burt Bacharach
12 May 1928
Kansas City, Missouri
USA

Burt Bacharach studied music at McGill University, the Mannes School of Music, and the Music Academy of the West. He spent two years in the army playing piano before teaming up with lyricist Hal David in 1957. The pair wrote twenty-two Top 40 hits for Dionne Warwick, including "Do You Know the Way to San Jose?", as well as songs for many other performers. Bacharach's fifty-year run on the charts includes seventy Top 40 hits in the USA, fifty-two Top 40 hits in the UK, over five hundred compositions, three Academy Awards (two for "Raindrops Keep Falling on My Head" and one for "Arthur's Theme"), and six Grammy Awards.

Frederik Bolkestein
4 April 1933
Amsterdam, North Holland
The Netherlands

Frederik Bolkestein received his Bachelor of Science from the London School of Economics in 1963, and his Master of Laws degree from Leiden University in 1965. Bolkestein worked for Royal Dutch Shell for fifteen years before entering Dutch politics. He served as the European Commissioner for the internal market, taxation, and the customs union from 1999 to 2004, where he spearheaded what is now known as the "Bolkestein Directive," aimed at creating a single market for service in the European Union.

Dave Brubeck
6 December 1920
Concord, California
USA

Dave Brubeck studied music at the University of the Pacific. He graduated in 1942 before serving in the US Army. After World War Two he continued his studies at Mills College under Darius Milhaud, who encouraged him to play jazz. In 1951, he formed the Dave Brubeck Quartet and released albums such as *Jazz Goes to College*. Brubeck's music is notable for unusual time signatures and his 1959 album *Time Out* included "Take Five" set in 5/4 time, which has become a jazz standard. He received a Grammy Lifetime Achievement Award in 1996.

Chuck Close
5 July 1940
Monroe, Washington
USA

Chuck Close studied art at the University of Washington and Yale University before winning a Fulbright scholarship to Vienna. His first solo exhibition in 1970 demonstrated his photorealism technique of breaking photographs into a grid and enlarging the contents of each square by hand, an approach for which he was to become well-known through his massive-scale portraits. In 1988, Close suffered a spinal blood clot that left him partially paralyzed and wheelchair-bound, but he continued to paint with a brush strapped onto his fingers. In 1998, New York's Museum of Modern Art mounted a major exhibition of his work.

Billy Connolly
24 November 1942
Glasgow
Scotland

Billy Connolly left school at the age of fifteen to become a shipyard welder before forming a folk-pop duo called The Humblebums, who recorded three albums. His first solo album, *Billy Connolly Live!*, released in 1972, featured Connolly as a singer-songwriter and musician but it wasn't until he appeared on BBC's *Parkinson* in 1975 that he became a household name as a comedian. In 2003, he was awarded a CBE (Commander of the British Empire) and a BAFTA Lifetime Achievement Award.

Bryce Courtenay
14 August 1933
Johannesburg, Gauteng
South Africa

A naturalized Australian, Bryce Courtenay's early years, before boarding school, were spent in a village in the Lebombo Mountains of South Africa. He later won a British university scholarship but was banned from returning to South Africa as a result of "politically unacceptable activity." Courtenay emigrated to Australia in the late 1950s and worked in advertising before taking up writing at the age of fifty-five. His first book, *The Power of One,* became an enduring bestseller. He has subsequently written over twenty books and remains one of Australia's most successful authors.

Judi Dench
9 December 1934
York, North Yorkshire
England

Considered one of the greatest actors of post-war Britain, Judi Dench trained at the Central School of Speech and Drama. In 1958, she made her Broadway debut in *Twelfth Night* and three years later she helped form the Royal Shakespeare Company. She broke into film in 1964, winning a BAFTA four years later for the TV series *Talking to a Stranger.* Her many awards include six Laurence Olivier Awards, a Tony, two Golden Globes, an Academy Award, and nine BAFTA awards. In 1988, she was awarded a DBE (Dame Commander of the British Empire) and, in 2005, a CHDBE (Companion of Honour).

Clint Eastwood
31 May 1930
San Francisco, California
USA

Clint Eastwood first found fame
in 1959 in the television series
Rawhide. He gained international
stardom as a hired gun in the
"spaghetti" Western *A Fistful of
Dollars* (1964) and its sequels
For a Few Dollars More and *The
Good, the Bad and the Ugly*.
Eastwood also starred in non-
Westerns, such as 1971's *Dirty
Harry*; a year that also saw his
directorial debut with the thriller
Play Misty for Me. He has
continued to direct, and star in,
a variety of movies, winning five
Academy Awards as well as the
Irving G. Thalberg Award for
lifetime achievement in film
production. In 2007, Eastwood
was awarded the National Order
of the Legion of Honour (France).

Garret FitzGerald
9 February 1926
Dublin
Ireland

Garret FitzGerald was one of the
Republic of Ireland's most
popular politicians and was its
Taoiseach (prime minister) twice,
from July 1981 – February 1982
and again from December 1982 –
March 1987. He obtained a BA
and Ph.D. from University College
Dublin and entered the Irish
Senate in 1965 and the House of
Representatives in 1969. In 1973,
FitzGerald became Minister for
Foreign Affairs and when his
party, Fine Gael, was defeated in
1977 he became leader and led a
minority coalition government in
1981. He resigned as party leader
after the 1987 election defeat,
and retired in 1992.

Malcolm Fraser
21 May 1930
Melbourne, Victoria
Australia

Malcolm Fraser attended
Melbourne Grammar School
and the University of Oxford.
He returned to Australia to enter
politics and won the seat of
Wannon in Victoria for the Liberal
Party at the age of twenty four.
Fraser was appointed Minister
for the Army in 1966, and was an
outspoken advocate of both
conscription and the Vietnam War.
He later served as Minister for
Education and Science and
Minister of Defense. Fraser was
elected leader of the Liberal Party
in 1975 and became Prime
Minister the same year, a position
he held for three consecutive
terms. He received the Human
Rights Medal (Australia) in 2000.

Frank Gehry
28 February 1929
Toronto, Ontario
Canada

Frank Gehry moved to Los
Angeles in 1947 with his family,
later studying architecture at the
University of Southern California
and city planning at the Harvard
Graduate School of Design. His
name soon became synonymous
with sculptural buildings often
clad in chain link or other
inexpensive materials. Powered
by a belief in architecture as
an art form, Gehry's buildings
include the ING Office Building
or "Dancing House" in Prague
(1996), the Guggenheim Museum
in Bilbao (1997), the Walt Disney
Concert Hall in Los Angeles
(2003), and his own home in
Santa Monica. In 1989, Gehry
won the Pritzker Prize and in 2003
was awarded the Companion
of the Order of Canada.

Jane Goodall
3 April 1934
London
England

Regarded as one of the world's
authorities on chimpanzees, and
the only human ever accepted
into chimpanzee society, Jane
Goodall began work as a
secretary and film production
assistant before traveling to
Kenya, where she met
anthropologist Louis Leakey,
who helped her establish the
Gombe Reserve project to study
chimpanzees in the wild. She
pioneered the study of
chimpanzee behavior and
society in the wild, observing
that chimpanzees are
omnivorous, make tools and
weapons, and have a primitive
"language" system. A renowned
conservationist, Goodall has
published numerous articles and
books, and in 2003 was awarded
a DBE (Dame Commander of
the British Empire).

Nadine Gordimer
20 November 1923
Springs, Gauteng
South Africa

Nadine Gordimer published her
first short story at the age of
fifteen and went on to complete
fourteen novels, nineteen short-
story collections, several works
of non-fiction, and a number of
television scripts based on her
works. Her writings center on the
effects of apartheid, of which she
was a passionate opponent, and
have been translated into forty
languages even though many of
them were banned in South
Africa. In 1974, Gordimer won the
Booker Prize for Fiction for *The
Conservationist*. She was
awarded the Nobel Prize for
Literature in 1991, and in 2007
became a Knight of the National
Order of the Legion of Honour
(France).

Harald zur Hausen
11 March 1936
Gelsenkirchen, North Rhine-Westphalia
Germany

Harald zur Hausen received his
Doctor of Medicine degree in
1960 from the University of
Düsseldorf. In 1965, he moved to
Philadelphia, where he contributed
to the discovery that a cancer
virus can transform healthy cells
into cancer cells. In 1983, zur
Hausen further developed this
finding when he identified two
versions of human papillomavirus
DNA as being the cause of about
seventy percent of human
cervical cancer cases. This
finding led to the creation of a
vaccine for HPV in 2006.
Zur Hausen shared the 2008
Nobel Prize in Physiology or
Medicine with Luc Montagnier
and Françoise Barré-Sinoussi.

Václav Havel
5 October 1936
Prague
Czech Republic

Because he was born into a
bourgeois family, Václav Havel
was barred from post-secondary
education in Communist
Czechoslovakia. He worked in
theater and became a playwright,
satirizing his country's totalitarian
regime, which led to numerous
imprisonments. In 1989, he
became a leader of Civic Forum, a
coalition struggling for democratic
reform, and when the Communist
regime capitulated, Havel became
the first non-Communist president
since 1948. The Federation
dissolved in 1992 and he was
elected first President of the new
Czech Republic, serving from
1993–2003. In 2003, Havel was
awarded the Gandhi Peace Prize.

Helmut Jahn
4 January 1940
Allersberg, Bavaria
Germany

Helmut Jahn studied architecture
in Munich before emigrating to the
US and furthering his studies at
the Illinois Institute of Technology
in Chicago. In 1967, he joined
C.F. Murphy Associates, which
was renamed Murphy/Jahn in
1981. Some of Jahn's most
recognized designs include the
State of Illinois Center in Chicago,
the Sony Center in Berlin, and the
HALO Headquarters in Niles,
Illinois. In 2002, he received the
Institute Honor Award of the
American Institute of Architects
for the Sony Center.

Edward M. Kennedy
22 February 1932
Boston, Massachusetts
USA

The youngest of eight siblings, including former President John F. Kennedy and Senator Robert F. Kennedy, Edward M. Kennedy was educated at Harvard University, the International Law School (The Hague), and University of Virginia Law School. In 1962, he was elected senator for Massachusetts and is currently the second-longest-serving senator in the USA. He is a prominent advocate for social policies such as national health insurance, consumer protection, and social welfare.

Billie Jean King
22 November 1943
Long Beach, California
USA

Billie Jean King won twelve Grand Slam singles titles, sixteen Grand Slam women's doubles titles, and eleven Grand Slam mixed doubles titles over the course of her career. The tennis match for which she is best remembered is the "Battle of the Sexes" in 1973, in which she defeated former Wimbledon men's champion, Bobby Riggs. The same year she founded the Women's Tennis Association. King has been inducted into the Women's Sports Hall of Fame (1980), the International Tennis Hall of Fame (1987), and the National Women's Hall of Fame (1990).

Juan José Linz
24 December 1926
Bonn, North Rhine-Westphalia
Germany

Juan José Linz was raised in Spain and gained degrees in economics, political science, and law at the University of Madrid. His studies on democracy and dictatorships, and their effects on a society, have made Linz a leader in the school of sociology. His seminal work, *Totalitarian and Authoritarian Regimes*, was published in 2000. Linz is presently Sterling Professor Emeritus of Political and Social Science at Yale University. He is also an honorary member of the Scientific Council at the Juan March Institute.

Jimmy Little
1937
Cummeragunga, New South Wales
Australia

After leaving school at the age of fifteen, Australian aboriginal Jimmy Little drew on his family background in music to launch his career. He made his radio debut as a teenager and toured with the Grand Ole Opry out of Nashville, Tennessee, in 1957 His first Australian hit came in 1959 with "Danny Boy," followed by many others including "Royal Telephone" in 1963. Along with a successful music career, Little has appeared in film and on television as well as teaching and mentoring Aboriginal people, a role which has earned him the moniker "Father of Reconciliation." He was awarded the Order of Australia in 2004.

Esther Mahlangu
11 November 1935
Middleburg, Mpumalanga
South Africa

In the tradition of the Ndebele, Esther Mahlangu was taught how to paint by her grandmother and mother at the age of ten, but her artistic flair emerged when, at puberty, she was taught the traditional craft of beadwork. As a teenager, Mahlangu became an expert in executing the traditional Ndebele art of wall painting and she was the first person to transfer the mural art form to canvas. Her work has been exhibited around the world, and in 1991 she became the first woman invited to paint a BMW car in the Art Car Collection, joining a group of artists that include David Hockney and Andy Warhol. She was also commissioned to paint the tail of a British Airways plane.

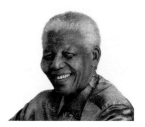

Nelson Mandela
18 July 1918
Mvezo, Eastern Cape
(formerly in the Transkei)
South Africa

Nelson Mandela qualified in law in 1942 and two years later joined the African National Congress (ANC). Anti-discrimination activities led to his arrest for treason in 1956, although he was acquitted in 1961 before being rearrested in 1962. While still incarcerated, he stood trial with other ANC leaders for plotting to overthrow the government and was sentenced to life imprisonment, a term he served mainly on Robben Island. His reputation grew during his twenty-seven-year-long imprisonment, and after his release in 1990 he worked tirelessly to create a new multi-racial South Africa. In 1993 he shared the Nobel Peace Prize with F.W. de Klerk, and the following year became South Africa's first democratically elected President (1994–1999).

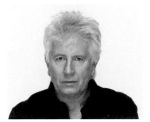

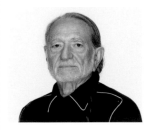

Kurt Masur
18 July 1927
Brieg, Silesia
Poland
(formerly in Germany)

Conductor Kurt Masur studied piano and cello in Breslau, and then moved to the Leipzig Conservatory to study piano, conducting, and composition. Masur has directed orchestras around the world, notably the New York Philharmonic, the Orchestre National de France, the Leipzig Gewandhaus Orchestra, the London Philharmonic and the Israel Philharmonic. He has made more than one hundred recordings and received numerous honors including the Cross with Star of the Order of Merits (Germany, 1995), the Gold Medal of Honor for Music (National Arts Club, USA, 1996), Commander of the National Order of the Legion of Honour (France, 1997), and the Commander Cross of Merit (Poland,1999).

Graham Nash
2 February 1942
Blackpool, Lancashire
England

Musician and photographer Graham Nash co-founded The Hollies in 1961, one of the UK's most successful groups whose hits included "On a Carousel." In 1968, he moved to the USA and formed Crosby, Stills & Nash, whose first release was the hit "Marrakesh Express," written by Nash. In 1969, they performed at Woodstock, the same year their first album won a Grammy Award. In 1990, he co-founded Nash Editions, a digital printmaking company, which was recognized in 2005 by the Smithsonian Institution for its role in the invention of digital fine art printing.

Willie Nelson
30 April 1933
Abbott, Texas
USA

American country music star Willie Nelson wrote his first song at the age of seven and was playing in a local band by the age of nine. After stints as a DJ and in the air force, his song "Crazy," recorded by Patsy Cline, reached number one in 1961. His breakthrough as a performer did not come until the following decade with alternative country albums such as *Red Headed Stranger* (1975), featuring the hit "Blue Eyes Crying in the Rain," which won him one of ten Grammy awards. Nelson has also had many television and film roles, and is a well-known social activist, working among other things to promote biofuels and the decriminalization of marijuana.

Rupert Neudeck
14 May 1939
Gdańsk, Pomorskie
(formerly Free City of Danzig)
Poland

Neudeck lived in Danzig until his family had to flee the city after World War Two, when it came under Polish rule. He attended college in West Germany, and later worked as a correspondent for a German radio station. In 1978 he founded Cap Anamur, an organization focused on helping refugees from countries in turmoil. More recently, Neudeck founded Gruenhelme (Green Helmets), which reconstructs villages in destroyed regions.

Nick Nolte
8 February 1941
Omaha, Nebraska
USA

Nick Nolte attended Arizona State University on a football scholarship but dropped out to become an actor at the Pasadena Playhouse. He studied at Stella Adler Academy in Los Angeles and traveled for several years, performing in regional theaters. A breakthrough role in the 1976 television series *Rich Man, Poor Man* earned Nolte an Emmy Award nomination, and since then he has played a wide variety of characters in more than fifty films, earning two Academy Award nominations and winning a Golden Globe, as well as a New York Film Critics Circle Award for Best Actor.

Yoko Ono
18 February 1933
Tokyo, Kanto
Japan

Yoko Ono moved to New York at the age of eighteen and gained notoriety when she opened the Chambers Street Series in her loft, where she presented some of her earliest conceptual and performance artwork. In 1966, Ono met John Lennon and they started their highly publicized relationship. Ono continues to create performance and abstract pieces. Her recent work, *Sky Ladders*, was unveiled at the 2008 Liverpool Biennial.

Michael Parkinson
28 March 1935
Cudworth, South Yorkshire
England

Michael Parkinson has interviewed over two thousand people on his eponymous show. He began his career as a journalist before moving into television current affairs. In 1971 he began hosting *Parkinson,* which ran until 2007, interviewing guests as diverse as Muhammad Ali and Miss Piggy. He was awarded a CBE (Commander of the British Empire) for services to broadcasting in 2000, and in 2008 was made a Knight Bachelor.

Jacques Pépin
18 December 1935
Bourg-en-Bresse, Ain
France

One of America's best-known chefs, Pépin trained in Paris at the Plaza Athénée. He was chef to three French heads of state, including Charles de Gaulle, before moving to the USA in 1959, where he studied French literature at Columbia University. He has published twenty-five cookbooks and hosted nine television cooking series, and his most famous book, *La Technique,* is considered a seminal text on the principles of French cuisine. In 2004, Pépin became a Knight of the National Order of the Legion of Honour (France).

Rosamunde Pilcher
22 September 1924
Lelant, Cornwall
England

Internationally best-selling author Rosamunde Pilcher served in the Women's Royal Naval Service during World War Two, and the first of ten novels, written under the pseudonym Jane Fraser, was published in 1951. Four years later, Pilcher began writing under her own name and international fame came in 1987 when *The Shell Seekers* topped the *New York Times* bestseller list. Several of her novels have been made into films and television series. In 2002, she was awarded an OBE (Order of the British Empire).

Mary Quant
11 February 1934
London
England

Sixties British fashion diva Mary Quant is widely credited with inventing the miniskirt and hot pants. After gaining experience as a milliner, she opened her own shop, Bazaar, on London's King's Road in 1955. Quant began designing her own clothes and by 1961 had a second shop in Knightsbridge. Her internationally famous style was known as "Chelsea Girl," and included the micro-mini, plastic raincoats, and "paint box" make-up. In 1966, she was awarded an OBE (Order of the British Empire) for services to the fashion industry.

Bernice Johnson Reagon
4 October 1942
Albany, Georgia
USA

While a student at Albany State College, Bernice Johnson Reagon was arrested for demonstrating and spent a night in jail singing songs, which inspired her to use music as a tool for activism. In 1973, she founded Sweet Honey in the Rock, an award-winning a cappella quintet performing traditional African and African-American music. From 1974–1993 Reagon worked as a curator for the Smithsonian Institute and she was a professor of history at American University from 1993–2002. She was awarded the Charles Frankel Prize in 1995 by President Clinton.

Robert Redford
18 August 1937
Santa Monica, California
USA

Robert Redford studied acting at the New York American Academy of Dramatic Arts and debuted on Broadway in 1959. During the 1960s, he appeared in television dramas such as *Alfred Hitchcock Presents* before starring alongside Paul Newman in *Butch Cassidy and the Sundance Kid* in 1969. Many box office hits followed, and in 1980 Redford turned to directing with *Ordinary People*, for which he won an Academy Award for Best Director. In 1980, Redford established the Sundance Institute, which sponsors the annual Sundance Film Festival. In 2002, he received an Academy Lifetime Achievement Award.

Ravi Shankar
7 April 1920
Varanasi, Uttar Pradesh
India

Ravi Shankar is one of the leading Indian musicians of the modern era. A legend in India and abroad, Shankar has melded Indian music into Western forms: he has written concertos, ballets, and film scores. In the 1960s, Shankar attracted worldwide attention for appearing at the Monterey Pop Festival and Woodstock, and for teaching Beatle George Harrison to play the sitar. His film score for *Gandhi* earned him nominations for both Academy and Grammy awards, and he has received twelve honorary doctorates as well as the Bharat Ratna, India's highest civilian honor. In 1986, he became a member of the Rajya Sabha, India's Upper House of Parliament.

Wole Soyinka
13 July 1934
Abeokuta, Ogun
Nigeria

The first African recipient of the Nobel Prize for Literature (1986), Wole Soyinka studied at Government College, Ibadan, and the University of Leeds. Radical themes within his writings led to clashes with the Nigerian government: in 1967, an article on Biafra led to twenty-two months' imprisonment, and in 1994, Soyinka went into voluntary exile after being charged with treason. He was sentenced to death in his absence, but a change of government enabled his return in 1999. Soyinka has published over twenty works, including plays, novels, memoirs, and poetry.

Desmond Tutu
7 October 1931
Klerksdorp, Transvaal
South Africa

Desmond Mpilo Tutu, Archbishop Emeritus, began his career as a teacher before studying theology, and was ordained as an Anglican priest in 1960. In 1975, he became the first black Dean of St Mary's Cathedral in Johannesburg, followed by appointments as the Bishop of Lesotho, General Secretary of the South African Council of Churches, Anglican Archbishop of Cape Town, and Primate of the Church of the Province of South Africa. He gained international fame as an anti-apartheid activist in the 1980s and was awarded the Nobel Peace Prize in 1984 and the Gandhi Peace Prize in 2007.

Bill Withers
4 July 1938
Slab Fork, West Virginia
USA

After a childhood in the coal mining towns of West Virginia, Withers joined the navy at the age of seventeen and in 1967 moved to Los Angeles to pursue a music career. The single "Ain't No Sunshine," from his debut album, became an international hit, earning him the first of nine Grammy nominations. Withers's songs have been recorded by artists from almost every genre, and he has received numerous awards, including three Grammy Awards. He was inducted into the Songwriters Hall of Fame in 2005.

Andrew Wyeth
12 July 1917 – 16 January 2009
Chadds Ford, Pennsylvania
USA

Andrew Wyeth started drawing as a young child and was taught art formally by his father, a well-known illustrator. He worked primarily in watercolors and egg tempera, and his first one-man show in Maine in 1937, of watercolors painted around the family's summer home at Port Clyde, was the first of many successes. Wyeth was considered one of the world's most collectable living artists, and, in 1970, became the first artist to hold a one-man exhibition at the White House. He was awarded the Congressional Medal of Honor (USA) in 1988.

Federico Mayor Zaragoza
1934
Barcelona, Catalonia
Spain

Federico Mayor Zaragoza began his career as a biochemist after he obtained a doctorate in pharmacy from the Complutense University of Madrid in 1958. In 1974, he co-founded the Severo Ochoa Centre of Molecular Biology at the Autonomous University of Madrid. After many years spent in politics, Mayor became Director-General of UNESCO in 1987, a post he held until 1999, when he created the Foundation for a Culture of Peace, of which he is now the president. In addition to numerous scientific publications, Mayor has published four collections of poems and several books of essays.

ISBN 978-0-8109-8439-4 (U.S./Canada)
ISBN 978-0-8109-8473-8 (U.K.)

Produced and originated by PQ Blackwell Limited
116 Symonds Street, Auckland, New Zealand
www.pqblackwell.com

Concept and design copyright © 2009 PQ Blackwell Limited
Images, text, and footage copyright © 2009 Andrew Zuckerman
First published in *Wisdom* in 2008

Printed and bound in China

10 9 8 7 6 5 4 3 2 1

THE ART OF BOOKS SINCE 1949

115 West 18th Street
New York, NY 10011
www.abramsbooks.com

The publisher is grateful to the Nelson Mandela Foundation for
permission to reproduce Nelson Mandela's images and words
on pp. 76–77 and 153. "It is what we make out of what we have,
not what we are given, that separates one person from
another" from *Long Walk to Freedom* by Nelson R. Mandela.

Five percent of the originating publisher's revenue from the sale
of this book will be donated to a *Wisdom* royalty pool that will be
distributed evenly among charities nominated by the individuals
that appear in the book.